The Book of
Emma Reyes

Paris abril 28 de 196_

14, RUE COSSINI - (1_

querido German

Hoy a las doce del día partió _
Elysée el general de Gaulle, lle_
su único equipaje once millo_
ovecientos cuarenta y tres mil docie_
inta y tres NOES lanzados por
uce millones novecientos cuoren_
as mil docientos treinta y tres fr_
que lo han repudiado.

 Todavía con las fuerio_
de la hemosión que nos poch_
noticia, curiosamente me _
a la mente el recuerdo más _
que guardo de mi infancia.

 La casa en que viviamos
componía de una sola y única
muy pequeña sin ventanas y
una única puerta que daba
calle. esa pieza estaba si te_
en la carrera septima de un
popular que se llamaba San Cr_
en Bogotá. en frente a la

The Book of
Emma Reyes

A MEMOIR IN
CORRESPONDENCE

EMMA REYES

TRANSLATED WITH AN INTRODUCTION
BY DANIEL ALARCÓN

WEIDENFELD & NICOLSON

Originally published in Spanish as *Memorias por Correspondencia*
by Laguna Libros (Colombia) and Fundación Arte Vivo Otero Herrera
in 2012
First published in Great Britain in 2017
by Weidenfeld & Nicolson
an imprint of The Orion Publishing Group Ltd
Carmelite House, 50 Victoria Embankment
London EC4Y ODZ

An Hachette UK Company

1 3 5 7 9 10 8 6 4 2

A CIP catalogue record for this book
is available from the British Library.

ISBN (hardback) 978 1 4746 0659 2
ISBN (trade paperback) 978 1 4746 0660 8

Printed in Great Britain by Clays Ltd, St Ives plc

www.orionbooks.co.uk

CONTENTS

THE BOOK OF EMMA REYES

CONTENTS

INTRODUCTION

Every work of art—every book, every film, every painting—is an unlikely achievement. We know this instinctively, of course. The vision one has for any piece at the outset can never be more than partially fulfilled, limited as we are by our talent, our time, our ability to execute. Even so, some works of art feel more unlikely, more miraculous than others, and Emma Reyes's remarkable epistolary memoir is one of them.

It's best to say it plainly. The very fact that this book exists is extraordinary. Everything about it, from the author's backstory—her childhood in grinding poverty, abandoned by her mother in the Colombian countryside, her escape from a convent, her improbable life in Europe—to the fact that she managed, without any formal education, to write these beautiful, moving letters, maintaining the correspondence across decades; then, the manuscript's survival and eventual publication in Colombia—all of this is astonishing.

When she passed away in 2003, at the age of

eighty-four, Emma Reyes was known—to the extent she was known at all—primarily as a painter. She'd been living in Europe for decades, having escaped the most miserable, stultifying kind of poverty her native Colombia could offer a child, and established herself as a presence in France, a kind of godmother to Latin American artists and writers. As a painter she was a peripheral, if beloved, figure on the scene. Felipe González, editor at Laguna Libros, the independent house that published her memoir in April 2012, described those who knew Emma's painting as "very few, and very old." Still, over the course of her life, she was close with Diego Rivera and Frida Kahlo and rubbed shoulders with Alberto Moravia, Jean-Paul Sartre, Pier Paolo Pasolini, Enrico Prampolini, and Elsa Morante. She made a life for herself in Paris, later in Bordeaux, as part of a Latin American and European cultural elite.

Emma was, by all accounts, magnetic, a great storyteller, the kind of person who could hold a room rapt. The stories she told most often had to do with her childhood. Sometime in the late 1940s, she met the Colombian historian and critic Germán Arciniegas, who, like others before him, insisted she write it all down. She protested that she found it difficult to organize her thoughts, and so Arciniegas offered a solution: tell the story of your childhood in letters, he said. Write them to me. The first of the twenty-three letters collected here is dated from 1969; the last from 1997. They aren't evenly spaced; in fact, there was a gap of more than two decades. Apparently, sometime in the early 1970s, Arciniegas had Gabriel García Márquez over for dinner in

Bogotá. He was so excited about Emma's letters that he showed them to the future Nobel Prize laureate. Weeks later, Gabo telephoned Emma in Paris to tell her how much he'd enjoyed them, and she responded with fury. As she saw it, Arciniegas had betrayed their implicit agreement of confidentiality. Emma didn't write him another letter for more than twenty years.

She must have known, though, there was something special in the work. According to editor Felipe González, Emma was proud of her writing—not because it was good, but precisely because it *wasn't*, at least not in a conventional sense. "She wanted the book to be published with errors," González told me. "She cultivated her mistakes." Emma had no formal education to speak of; she was, in fact, illiterate until her late teens. Her grammar, punctuation, and spelling were plainly intuitive, and every sentence was hard earned, every error part of her inheritance, a reminder of the childhood she'd survived. The Colombian edition applied a light touch to the original. As a translator, I've tried to do the same, while silently correcting some of the more obvious errors.

None of which is to say her prose lacks sophistication. On the contrary, I don't think I've read many books of such power and grace, or that pack such an emotional wallop in so short a space. Her memoir begins in a garbage dump in Bogotá, narrating moments of uncommon dignity, moving from there to the countryside and back again, describing with a poetic dispassion the sorts of trauma that would break most people. Emma, somehow, does not break. Colombia,

or rather the version of the country that brought her up, the country described here, is classist, violent, provincial, prejudiced. The Catholic Church is unyielding in its cruelty, willing to pass judgment, even on little girls like Emma, no more than six or seven when she was abandoned by her mother and taken to a convent.

After escaping in her late teens, Emma fled to Buenos Aires, making her way across South America on foot, by train, by car, hitchhiking and working as a traveling saleswoman. When she arrived in the Argentine capital in 1943, she began to paint. She married in Uruguay and had a child in Paraguay in the years immediately after a disastrous war had crushed that nation's economy. She was living in a small town outside Asunción when it was overrun by a group of armed looters. They sacked her home, and her newborn, only a few months old, was killed before her eyes.

This tragedy comes after the book concludes—and still Emma does not break. Eventually she won a scholarship to study art in Paris. Her husband abandoned her, opting not to travel with her, and so she left for Europe alone, to start a new life. She paid for her trip by offering to paint the ship as it sailed across the Atlantic. She hadn't anticipated how difficult it would be and fell ill from the strain. On board the ship was a French doctor, who took care of her; they fell in love and eventually married. The years that followed took her to Mexico, the United States, Spain, and Israel. In Italy she drove a cab, and, so the story goes, she ran someone over in Rome, then fled the country before she could be arrested.

I find it easy to connect the dots between Emma's memoir and her work as a painter: She has a visual

artist's eye for detail. The first image that strikes you is the figurine built from garbage, created by the children's ingenuity, brought to life by their imagination, and finally destroyed by their lusts. And in the pages that follow are burning villages, endless rides across the barren plains, train stations that feel as lonely and terrifying as any in literature. There are towns that feel like outposts of civilization, sinister characters, cruel abandonments. The convent itself is a universe apart, with arcane rules and habits that Emma and her sister struggle to decipher. We see it all through Emma's eyes: Her vision is acute, detailed, remorseless, and true. There is no self-pity, only wonder, and that tone, so delicate and subtle, is perhaps the book's greatest achievement.

At some point in the 1990s, Emma resumed her correspondence with Germán Arciniegas. Before his death in 1999, Arciniegas had his secretary type up Emma's letters, and according to Felipe González, Emma herself corrected this manuscript before she passed away. It was shopped around, but no publishing house in Bogotá would take it.

When she died in 2003, Emma left fourteen chests full of papers, one of which she gave to Arte Vivo Otero Herrera, a family foundation that had supported her work for years. Camilo Otero, the foundation's director, went through the documents and found references to the letters. On a trip to Bogotá he contacted the Arciniegas family, who still had the letters Emma had corrected. Otero took that manuscript to Laguna Libros in early 2012.

Calling Laguna a small operation would be an exaggeration. In fact, when Camilo Otero arrived with Emma's letters, it had only three employees. It specialized in art books, but before Emma Reyes, Laguna's bestseller was a collection of 1920s Colombian sci-fi. It had never had a second printing of any title in its catalog, and from a business point of view it was certainly a risk to publish a collection of letters by a dead painter whom few, if any, had ever heard of. Back then the employees of Laguna would deliver the books themselves, driving across Bogotá in Felipe González's station wagon. When they took Emma's published letters to stores in April 2012, González recalls that booksellers made fun of him.

But when they read the book, it all changed. Booksellers started talking about Emma Reyes. And, little by little, her memoir started to sell. The first print run of a thousand copies was sold out by September. And that was just the beginning. Against all odds, it became a runaway hit. A sixth edition has just been published.

My personal introduction to Emma Reyes was both unusual and typical of a book with such passionate fans—a stranger literally pressed it into my hands at the Bogotá Book Fair in 2014.

"You must read this," she said. "You have to."

Now I urge the same of you.

DANIEL ALARCÓN

The Book of
Emma Reyes

Letter Number 1

My dear Germán:

Today at noon General de Gaulle left Élysée, his only luggage the eleven million nine hundred forty-three thousand two hundred thirty-three NO votes cast by the Frenchmen who have repudiated him.

I had mixed feelings about this news, but curiously, it brought to mind my oldest childhood memory.

The house we lived in consisted of just one very small room with no windows, and a door that faced the street. This room was located on Carrera Séptima in a working-class neighborhood in Bogotá called San Cristóbal. The tram passed directly in front of our house and stopped a few meters ahead at a beer factory called Leona Pura and Leona Oscura. In that room lived my sister, Helena, another child whose name I didn't know whom we called Piojo, and a woman I remember only as an enormous tangle of black hair; it covered her completely, and when it was down I'd scream with fright and hide under the bed.

Our life took place in the streets. Every morning I would go to the garbage heap behind the beer factory to empty the bedpan we'd all used during the night. The bedpan was enormous and glazed with white enamel, little of which remained. Every day it was full to the very top, the odors that emerged from it so nauseating that I often threw up. There was no electric light or toilet in our room. Our toilet was that bedpan, where we did all our business. The trip to the garbage heap with that overflowing bedpan was the worst part of my day. I had to walk, scarcely breathing, eyes fixed on the shit, following its rhythm, possessed by terror that I might spill it, which would mean dreadful punishment. I gripped the bedpan firmly with both hands, as if I were carrying a precious object. The weight was also tremendous, a test of my strength. Because my sister was older, she had to go to the spigot to bring the water we needed for the day. As for Piojo, he had to go for coal and take out the ashes, so neither of them could ever help me carry the bedpan, since they went in the other direction. The best part of my day came once I'd emptied the bedpan on the garbage heap. That's where all the neighborhood kids hung out; playing, screaming, sliding down a mountain of clay, squabbling with each other, fighting. They rolled around the mud puddles and dug through the garbage looking for what we called treasures: cans of beer to make music, old shoes, pieces of wire or rubber, sticks, old dresses. Everything interested us; it was our game room. I couldn't play much because I was the smallest and the bigger kids didn't like me. My only friend was a boy we teased for his limp—we nicknamed him Cojo,

even though he was also the biggest of the children. He'd lost one foot completely, sliced off by the tram one day when he was arranging Leona bottle tops on the rails so the tram might flatten them like coins. Like the rest of us, Cojo didn't wear shoes, and he helped himself along with a stick, his only foot executing extraordinary leaps. When he started to run, no one could catch him.

Cojo was always waiting for me at the entrance to the dump. I emptied the bedpan, cleaned it quickly with weeds or old papers, and hid it in a hole, always the same one, behind a eucalyptus tree. One day Cojo didn't want to play because he had a stomachache, and we sat beneath the slide to watch the others play. The clay was wet, and I began to make a tiny figurine from it. Cojo always wore the same pair of pants, his only pair, three times his size, tied with a piece of rope around his waist. He hid everything in the pockets of those pants: rocks, spinning tops, pieces of glass, and a knife blade with its handle missing. When I finished the clay figurine, he took his half-knife and used the tip to make two holes for the eyes and another slightly bigger one for the mouth. But when he finished he said, "This doll is very small. Let's make it bigger."

And we made it bigger, adding mud to it.

The next day we returned, and it was lying where we'd left it. Cojo said, "We're going to make it bigger."

And the others came and said: "We're going to make it bigger."

One of them found an old, very large board, and we decided we'd make the figurine grow until he was that size, and then, atop that board, we could carry

him around, marching. For many days we added more and more mud to the figurine until he was as big as the board. Then we decided to give him a name: General Rebollo. I don't know why we chose that name, but it doesn't matter: General Rebollo became our God. We dressed him in whatever we found in the garbage heap; the races came to an end, the fighting, the leaping. Now everything revolved around General Rebollo, the central character in all our games. For days and days we lived around his board. Sometimes we made him seem good, sometimes evil; most of the time he was magical, possessed of superpowers. That's how many days passed, and many Sundays, which, for me, were the worst days of the week. From noon until the evening on Sundays, I was left alone, locked in our only room. There was no light other than what came through the cracks and the large keyhole, and I spent hours with my eye pressed to the hole to see what was happening in the street and to forget that I was afraid. Often, when the woman with long tangled hair and Helena and Piojo returned, they'd find me asleep against the door, exhausted from so much looking out, and so much dreaming of General Rebollo.

But after inspiring a thousand and one games, General Rebollo's heroism began to wane. Our tiny imaginations could find no more joy in his presence, and each day fewer and fewer of us wanted to play with him. General Rebollo began to spend long hours alone, no one taking care of the decorations that adorned him. Until one day, Cojo, who was still the most loyal, climbed atop an old bureau and pounded his improvised cane three times. His sharp

voice cracking with emotion, he shouted: "General Rebollo is dead!"

In circumstances like the ones in which we lived, one is born knowing what hunger, cold, and death mean. With our heads bowed and our eyes filled with tears, we slowly gathered around General Rebollo.

Once again, Cojo shouted, "On your knees!"

We all bent a knee, drowning in tears, no one daring to say a word. The son of the coalman was older than we were, and he always sat on a rock reading pages from the newspaper he found in the trash. He came toward us, still holding the newspaper, and said, "Idiot kids, if your General has died, then bury him."

Then he left.

We all stood. Together we lifted the board with the General, and decided to bury him in the garbage heap, but all our efforts were useless: we couldn't even move the board. So we decided to bury him in pieces. We broke each leg in three parts, did the same with the arms. Cojo said the head had to be buried whole. An old can was found, and we placed the head inside; four of the kids, the oldest ones, carried it first. We all followed behind, crying like orphans. The same ceremony was repeated with each of the pieces of the legs and the arms, until all that was left was his torso, which we broke into many pieces. We made many tiny mud balls from it, and when there was nothing left of General Rebollo's torso, we played war with them.

Emma Reyes
Paris, April 28, 1969

Letter Number 2

My dear Germán:

In spite of your very discreet letter, I can tell you're dying to know who the woman with the long hair was. The truth is the memories are blurry, and if I've managed to maintain a certain coherence to them through the years, it's because of my sister, who is two years older and remembers a bit more.

The long-haired woman was named María. She was very young, tall, and thin; she never spoke to us about her family or her life. Our dealings with her were limited to answering her orders with refusals or questions. She was tough and severe.

The only person who visited us was Mrs. Secundina, who had a store on Santa Barbara. She was much older, and was María's only friend. As soon as Secundina arrived, they'd send us into the streets to play, with the order not to come back until we'd been called. We never knew what they talked about. We'd buried General Rebollo not long before. I still had the same mud-stained dress. We always slept in our

clothes; María only took off her long skirt and undid her hair. One morning she woke very early. It was still black like night. She sent the three of us to empty the bedpan and bring back the buckets and the jar full of water. When we came back she turned on the small gas burner and put the big pot on to boil. While the water warmed, she changed the sheets and cleaned the four pieces of furniture we owned.

"Take off your clothes," she said. "I'm going to give you a bath."

It was the first time she bathed us all at the same time. The three nudes stood around the basin, and she soaped us quickly and then rinsed us one by one, using a wooden bowl. The floor of our room was soaked and sudsy; before dressing us, she put us to work drying it. She dressed us in our Sunday best, and we sat on the edge of the bed, under orders not to move. Before long she too had put on her Sunday dress, then brushed her hair very carefully, asking Helena to hold the mirror and Piojo to hold the candle. She'd get furious each time one of the two would move. When she was finished, she sent Piojo to the factory to see what time it was. She didn't give us any breakfast that day; she was nervous, circling the room like a caged beast. Day had dawned, but she didn't open the door as she usually did, and we remained in the candlelight. Suddenly, there were three soft knocks on the door, and she crossed herself and hurried to open it. A very tall and slim man appeared, dressed unlike the people in our neighborhood. He was like those men we saw in the newspapers we found in the garbage dump. He wore an overcoat and a hat and carried an umbrella, all dark, perhaps

black. He passed his hand over his eyes, as if to acclimate to the candlelight, and entered as if slipping through the door. He gave her a kiss on the cheek, and all three of us laughed at once. It was the first time a gentleman had been in our room.

Mrs. María shut the door, locked it, and took the bottle with the candle and came to the bed, where we still sat, paralyzed. He followed her, wearing a serious expression. She brought the candle close to Piojo's face and said to the man:

"This is Eduardo. He's yours."

The man patted Piojo lightly on the cheek with his palm.

Then she showed him Helena, and then me. Nothing was said; there was a profound silence. The gentleman unbuttoned his overcoat and his jacket, and with the tips of his fingers took some coins from the pocket of his vest. He gave three to Eduardo and one to each of us.

"Say thank you," Mrs. María said, "and now go play outside, but stay near the door, and if you see a neighbor coming, tell her I'm still asleep."

We went out and heard the lock turn behind us. The man was there a long time. Finally, the door opened. Mrs. María stuck her head out and made sure no one was watching. She turned and said, "Okay. Now."

The man left, scurrying out the way he'd come. He passed by without looking at us, as if he'd never seen us before. We watched him leave with large, bounding steps, staying close to the wall, as if he were afraid of being seen.

When we entered the room, Mrs. María was crying. She began to empty the drawers and separate

everything that belonged to Eduardo. She took out a cardboard box from beneath the bed and packed away everything she'd set aside.

"Helena and Emma, put on your old dresses. Eduardo, no, because he's coming with me."

She was still crying, so we also started to cry. While Helena undressed, we saw a stack of bills on the table, and I was scared. I felt something was about to happen. We had only coins; we'd never seen bills in the house. Mrs. María didn't say a word. She took a shawl from its box, wrapping it tight around her face. For the first time I saw that she looked like the Virgin from church.

"Don't move. I'm going to the neighbor's."

She came back with the neighbor, Cojo's mother. She showed her where the plates and candles were kept. She took the cardboard box with Piojo's clothes in it, stood before us, and told us she was going away for a few days, but that the neighbor would come by to bring us food. Because there was no one to take care of us, she'd leave us locked inside. "Behave," she repeated twice, then shuffled Piojo to the door, placed a seaman's beret on his head, and ordered him out. Piojo looked at us, his big, open eyes filling with tears.

We spent many days and nights locked in that room. We lost count of how many. The bedpan filled up with our shit, so we started using the large serving plate. The neighbor came by only once a day and left us a big pot of porridge. "Don't eat it all at once," she'd say, "because I'm not coming back until tomorrow. And blow out the candle as soon as you're done eating."

We cried and screamed so much that the neighbors came to the door to try to console us. For hours, we'd

look through the keyhole and the cracks in the wood to see if she was coming. Finally, she came back one day, and found us asleep on the floor, our backs against the door. It was the first time we both threw ourselves on her neck, hugging her and kissing her with happiness. She started to cry, very sweetly removed our arms from around her neck, and, holding our hands between hers, said: "Piojo isn't coming back. His father, that man who came here, is an important politician. He may become the president of the republic. That's why he didn't want his son to be here. He says he's afraid and prefers to deal with him himself; I took him far from Bogotá, to Tunja, and left him in a convent where everything had been arranged so they could take him in."

Without Piojo, I felt lost. I cried and screamed; I called his name. I didn't understand what "far from Bogotá" meant. I thought that if I shouted loud enough he might hear me. Mrs. María also seemed very sad. She became quieter and tougher. I think this was when a secret pact was born between Helena and me, an unconscious notion that we were alone and belonged only to each other. In that moment I didn't know that I'd never see Piojo again, and that I'd be left with just the memory of his immense black eyes full of tears, beneath that ridiculous seaman's beret.

Letter Number 3

My dear Germán:

As I said in my previous letter, after Piojo, or Eduardo, left, Mrs. María became more indifferent toward us and crueler. She hardly spoke beyond what was strictly necessary and began to go out into the streets almost every day. She'd wake us very early and give us breakfast. I had to run out to empty the bedpan on the garbage heap, and Helena brought the water. Sometimes I helped her, but the jar and the bucket were too heavy for me and I'd spill half the water. As usual, Mrs. María would leave us locked in the room while she was out, and sometimes she returned only at night, not concerning herself with whether or not we'd eaten.

One night she came back very, very late. We were crying with hunger. She was carrying packages, and for the first time she brought us some pastries and guava snacks. She made us dinner, and without warning, she started to laugh, a wild laughter. Tears streamed down her face, and we were frightened, not

knowing if we should laugh with her or cry. When she managed to calm down a little, she pounded the table and said: "We're leaving this miserable room. Tomorrow we pack up, and we're going to a town far from here and we'll have a big house."

She started laughing again and ordered us off to bed, since we had to be up early.

For many days the room was hell—nothing was in its usual place and the dresser was empty while she made piles of various things in every corner. One morning she went out and bought three big trunks and began to pack up the clothes and the plates. She wrapped every plate carefully among the linens and the towels; in the last trunk she packed the pots, the serving bowl, the jar, and the bedpan. By evening the room was bare except for the furniture. The mattress had no sheets or blankets, and various boxes full of old things were strewn on the floor. After dinner the neighbors came and took what they wanted. Cojo's mom took the old broom; we sold the bed to a worker from the beer factory. When everyone was gone, all that remained were the three closed trunks in the middle of the room and the old mattress on the floor. Cojo's mom came back and brought us a blanket and a bedpan.

It was still dark when we woke up. We wore our Sunday dresses, the only ones we'd left unpacked. Mrs. María sent us to the neighbor's to return the blanket, the bedpan, and the dirty clothes we'd taken off the day before. When we came back Mrs. María was waiting for us by the door; she'd already put on her shawl, and she had a new leather briefcase. She locked us in the room with the three trunks and said

she wouldn't be long. Not long after, we heard the sound of a horse, and we looked through the keyhole and saw her, descending from a buggy that had stopped in front of the door. The neighbors hurried out and helped get the trunks into the buggy. They sat me among the trunks, and Helena stood, holding me so I wouldn't fall.

Mrs. María greeted everyone with a handshake; in that moment we saw Cojo running toward us. He came right up to the buggy and gave me half of an orange that he had in his hand, then watched us with very sad eyes. Mrs. María locked the door and gave the key to the neighbor, asking her to take care of the room.

I didn't see what happened next, only heard a horrible cry. When I turned, Mrs. María was prone on the sidewalk, her eyes closed and blood coming out of her mouth. The driver said all manner of vulgarities. Helena says that Mrs. María tried to walk in front of the horse to greet the priest, and that the horse raised its frightened head and hit her in the jaw. She bit her tongue from the shock, and fell like a dead person in the middle of the sidewalk. The neighbors brought alcohol and lotions and started rubbing her forehead. We wept like lunatics, calling her name and pulling at her sleeve. Finally she opened her eyes, and little by little sat up. She was pale, and we all went inside Cojo's mother's house. They made her gargle salt water, and the priest said it was best to scrub her face with menthol ointment. The neighbor said candle wax was better. Meanwhile we kept crying, and the driver was furious because he was losing time. The worker who'd bought our bed folded a handkerchief, held it

to Mrs. María's jaw, and tied it in a knot around her head. The neighbors helped replace her shawl, and after a thousand more bits of advice and farewells, we got back in the buggy. I can still see the neighbors in the middle of the street, their arms raised high, waving good-bye. In the midst of it all, I lost that half of an orange that Cojo had given me.

Letter Number 4

My dear Germán:

If it's true that certain moments in our childhood mark us forever, then that ride was one of them. It signaled the end of our lives in that room in Barrio San Cristóbal (patron saint of travelers) and was the beginning of a life that would take me along America's most difficult roads, and later the fabulous ones of Europe.

The buggy took us to the Sabana station. Mrs. María didn't say a word for the entire trip. She was so pale and so sad that I asked her again if she was going to die, and with a wave of her hand she answered no. We rode along so many grand streets, past houses with balconies, and churches, that I didn't know where to look; the fright from having seen Mrs. María stretched across the street like General Rebollo on the garbage pile had left me with a stomachache and an urge to vomit.

At the station, Mrs. María called some men to carry our trunks. There were people running in every

direction, all weighed down with suitcases, bags, and backpacks; I held on to Mrs. María's dress, and Helena took my other hand. We walked in circles; Mrs. María spoke with various people and opened her handbag again and again, giving out money in exchange for little pieces of paper that she would put away. At last we boarded a train, and she sat by the window. She made Helena sit next to her and sat me on her knees. It was the first time she'd carried me. I didn't know what to do. She smelled strongly and unpleasantly of medicine, and I was afraid my head might touch her face. People kept shoving their way onto the train, bulging with packages. Some men came aboard, shouting and carrying tiny four-stringed *tiples** and a bottle. They began to sing, and I fell asleep before the train even departed.

They woke me when it was time to get off. It was already dark when Mrs. María showed up at the door of a big house. We were received by the owner, a very fat woman with a red nose who was dressed in all black.

The fat woman took us to a large room that faced an inner courtyard full of plants hanging from the ceiling, as if they'd been planted in the sky. She summoned an unkempt teenage boy who had a toy top in one hand and told him to go to the kitchen and let them know that there would be three more people for dinner. Mrs. María told the owner what had happened with the horse before we'd left. The owner said she'd call a healer who cured people by applying heated frogs wherever there was pain. Mrs. María wouldn't agree to this, so we ate and then went to bed.

* A *tiple* is a small four-string guitar.

We stayed in that village, whose name I never learned, for many days. Mrs. María went out almost every day and got in the habit of taking Helena with her, leaving me in the care of the ratty teenager, who'd sit beside me, playing with his spinning top. One day he made it dance on his hand, and I was so frightened I started to cry; another day he asked me if I had a dad and a mom, and I asked him what those were, and he said he didn't know either.

On the last day Mrs. María left very early. When she returned she was weighed down with packages and called us to the room and had us undress. She'd bought us new dresses. Helena's was blue—which I liked more—and mine was pink; both had buttons and lace. They were lovely. Once we were dressed, Mrs. María made us go out to the patio. A while later she came out of the room and we almost didn't recognize her. She was so beautiful and looked so young. She'd bought a gray dress with many pleats and buttons and washers, black boots that also had many buttons, and a large gray hat with a kind of veil that cinched below her chin. Everyone came up to her and congratulated her; the owner touched her everywhere. They called the kid so he could help us carry the packages. We walked many blocks and came to a kind of pasture full of horses and other scary animals I'd never seen before, and Helena told me that these animals made the milk we drank with our coffee at breakfast. There were groups of men called Indians because they were dressed differently from the men of Bogotá. Mrs. María spoke to many of them and asked each for Mr. Toribio.

Toribio was an Indian, much larger than the rest, strong, almost fat, with small eyes that you could

hardly see. He said the horses were nearly ready and that all we had to do was wait for the Indians to come with the trunks. Another Indian came with the horses, all of them big except a little one with long ears, which Toribio said was called Burro.

Burro had two seats tied to him, one hanging from each side of his belly. Above the seats was a kind of tent made from a sheet hanging between poles tied to the backrests of the seats. Toribio said this was so the sun wouldn't sting. We were picked up and put in the seats, one on either side. Since Helena was bigger, her seat went down and mine went up. Toribio said we'd have to tie a sack full of rocks to my seat, so both sides would stay level.

Mrs. María was helped up onto a horse as gray as her dress. The Indians tied the trunks to the other horses, which they called mules. When everything was ready, Toribio rode a big horse the color of milky coffee; a very dark-skinned Indian with a puffy face lassoed Burro and started to slap him so he'd walk; slowly we left the village behind, until we could see nothing, not even the houses or the church.

I don't remember the whole trip, because I slept almost the entire way, and when I woke up I cried because I was tired and had blisters on my legs. My entire body hurt, and on the last day I threw up many times. Toribio was very kind. He would come down from his horse, carry me, and have me walk a little.

It rained all of the last day, and the horses had mud up to their bellies. We barely moved, and it was almost ten in the evening before we'd arrived in. Toribio was furious with the Indians, and with Burro because he walked so slowly. In Guateque we went straight to a

large, two-story house very close to the plaza. There was a church and a large fountain with figurines spewing water from their mouths, as if they were vomiting.

Toribio got off his horse and went to knock on the front door, but no one answered. We waited awhile, until finally a woman from the house across the street came out and said she had a letter for Mrs. María. In the envelope was the key.

Beyond the front door, there was a corridor of white pebbles, and then a second door that led to a garden lush with plants and trees. The corridors around the garden were wide, with wooden columns, and the bedrooms faced the garden. Beyond the garden, the house was two stories high; everything else was just a single floor. There was a second interior courtyard—more of a brick patio—where there were two large ovens for baking bread, a kitchen, and more bedrooms. Behind the patio through a large door was where they kept everything for the horses. It was huge, and there were fruit trees—rose apple, mango, and guava.

The Indians unloaded the horses and left. Toribio came in with us and started opening doors and bringing chairs out to the corridor so we could sit. He told us not to go into the bedrooms since we were hot and the rooms were cold—after all, the house had been closed for many years.

Toribio asked if he could stay until the doctor arrived; Mrs. María asked him to sit and began to ask him lots of things about the town. Then someone threw a small white dog over the garden wall, and it landed in the middle of the garden. Its stomach was like a drum, and its eyes were open wide. Toribio said not to touch it because it had been poisoned. We were

gathered around the little dog when we heard the raspy voice of a man asking if the travelers from the capital had arrived yet. Mrs. María hurried to greet him. He gave her a hug, patting her on the back. Toribio took off his hat and bowed his head.

"How are you, Toribio? Have you taken good care of the lady and the girls? What the hell took you so long?"

"Yes, Doctor. We added a day because of Burro. That's what the girls call him. The plain was difficult because of the rains, and that burro has always been a pain when it comes to bad roads."

"It's all right, Toribio. Go to the smoke shop and wait for me there. And not a word in town about the travelers, if you ask me . . ."

"Yes, Doctor."

When Toribio left, the doctor sat at the edge of the patio. He took off his poncho, placed it on the ground, and told Mrs. María to sit next to him.

His name was Roberto. He was a lovely man, tall, thin, bronzed by the sun, with very pretty teeth and straight hair like an Indian. He wore tall leather boots with spurs, a wool suit, a kerchief tied around his neck, a white poncho, and a hat that Mrs. María called a cork hat. He carried a kind of whip in his hand, with which he gave his boots little snaps as he spoke. When Mrs. María sat next to him, he said to her, "You look lovely, miss."

She laughed. "I'm going to introduce you to the girls," she said. "Come. Get closer. This is the oldest; her name is Helena."

"She's very pretty," he said. "What beautiful eyes. Come. Give me your hand." Helena approached him

and sat on his lap. "And the other one, what's her name?"

"The other one is Emma, the baby, that's what Helena calls her. The poor thing, she's very ugly. Can you believe that every day she gets a little more cross-eyed?"

"Don't worry, María. I have a friend here. Dr. Vargas. He'll straighten out her eyes."

I started to cry.

"Why are you crying?" Roberto asked.

"Because you're going to take out my eyes."

The two of them started to laugh. "Dumb little girl, *straighten* doesn't mean *take out*." Through my tears I saw the dead dog again, the one who'd fallen from the sky. I ran to him, grabbed him with both hands, and threw him against Roberto's knees. That was the beginning and the end of our relationship. I didn't see him ever again, but his presence was never erased from my life.

Sir:

You make no corrections, and I don't even know if what I'm writing is comprehensible. There are moments that seem confusing to me, and I don't know if you can follow the story. I don't have a copy because I write to you directly, and I don't remember what I've written before.

Kisses for all.
 Emma
 Paris 9/69

Letter Number 5

My dear Germán:

Roberto B. belonged to Guateque's high society and was one of the richest men in Boyacá. He owned ranches with farmland and negotiated the sale of horses and cattle. He was married to a young woman from Tunja, but they had no children. When they got married, they moved to the house in Guateque—in other words, to the same house we went to upon arriving. They'd lived in that house for many years, while they built another beautiful home at one of their ranches on the banks of the Súnuba River. When they moved, the house in Guateque had stayed shuttered, and no one had lived there since.

Roberto never went out or traveled with his wife. She went out only with a maid to go to church in the village near the river.

Roberto was close friends with Eduardo's father; they'd studied together in Europe. Mrs. María had known him when she and Eduardo's father were together, when Eduardo was a newborn, and now,

through sheer coincidence, she found him again in Tunja, when she traveled to that city to abandon the child.

It was his idea that she come to Guateque, and he even wrote a letter to the owner of the chocolate factory, La Especial, asking them to put her in charge of the franchise in town.

The chocolate shop was in the town square, next to the church. The sidewalk was very high, almost a meter above street level, so that it was as if one were always on a balcony, with a towering view of the plaza. The shop had two large doors, floor-to-ceiling shelves, and a very high solid countertop. I was never able to see over it. Across from the counter, against the walls and between the two doors, were large benches where the visitors sat. The shop itself was attached to the house of one of the Montejo brothers, very important gentlemen in town. Behind one shelf was a very small space where Mrs. María had placed a tiny table so she could eat without being seen from the street. There was also a small door that opened into the Montejo house, so we could pee out on the back patio.

The day after our arrival, Toribio showed up again with a young Indian woman whom Dr. Roberto had sent to be our maid. Her name was Betzabé; she was petite, with a very squat neck, so short that you could see only her two nostrils, and with beautiful, lively eyes, nice teeth, and straight black hair in two tight braids. She wore very white espadrilles with black bows, a wide skirt of rough wool, and, beneath it, more skirts of soft red cloth. She covered her hair with a thin shawl, and wore a straw hat on top. She

was the daughter of one of the peasants who worked at one of Roberto's farms. The same day she arrived, Mrs. María went with her to the market and to get the keys to the shop from the Montejos.

Within a week we were so settled in Guateque that it was as if we'd lived there our entire lives.

After our arrival, Mrs. María had everyone call her *Miss* María. Nothing changed for us because we didn't call her anything; we just said, "Yes, ma'am" or "No, ma'am," and if she didn't talk to us, then we didn't say anything at all.

Miss María decided that Helena had to stay with her at the shop all day, in case an errand needed to be run, and so she could climb up the shelves to retrieve the pounds of chocolate. As for me, I was to stay at home with Betzabé, with the front door locked; she didn't want us to leave, or to play with other children in town from any social class; nor did she reach out to any family or make any friends. Betzabé would make lunch, and at noon she'd take Miss María a lunchbox and a basket with plates and utensils. She'd stay until they'd eaten and come back with the dirty dishes. Meanwhile, I'd stay in the house behind lock and key. Compared to my life in the room in San Cristóbal, in Bogotá, the house in Guateque was truly a paradise. At first I missed my friends from the garbage dump, but pretty soon I got used to being alone. Betzabé worked all day, cleaning the house and cooking; I strolled through the house, which seemed, and in fact was, enormous.

Miss María bought hens and a small pig, which I loved. Supposedly I kissed it on the mouth and fell asleep with it in my arms. Little by little I learned to

climb trees, without straying too far up, and beat down fruit with a cane. Naturally I got thousands of scrapes and bruises, but never anything serious. The hens took over the bread ovens (which we didn't use) to make their nests and lay their eggs. When I saw a hen step into the oven, I'd go in with her, and I'd lie still for hours, waiting for it to lay its egg, so I could take it, and hold it warm against my cheeks. When it cooled off, I'd run and take it to Betzabé. I'd sit beneath the trees, building houses of hay, picking flowers, talking to my pig for hours. He'd follow me all over the house, like a dog. In the morning, when he'd see me, he'd let out great squeals of delight; one time he got fleas, and we had to shave him and pick all the fleas out. I lived as dirty as that pig, with my arms, legs, and face covered in scratches.

Saturday was the best day, because Betzabé had to wash clothes in the river. We'd leave early in the morning. Betzabé would place the bundle of clothes on her head and carry a basket of food for the two of us. I'd take the pitcher for chocolate. It was a long way to the river, and every now and then Betzabé would carry me so we could go faster. The Súnuba seemed enormous to me; it was the first river I'd ever seen. On its banks were thick stands of trees—avocado, guava, orange. We'd always go to the same spot, where the river curved and we could see the bridge. As soon as we arrived, Betzabé would lather the clothes with soap, then spread them out on the grass in the sun. Then we'd go to gather firewood and pick fruit; when we returned, we'd make a fire and heat up a pot of potatoes and corn. While the soup was cooking, Betzabé would rinse the clothes, and I'd

tend to the fire and the pot. When she was finished laying out the clothes, we'd get undressed. She'd wear a long bathing suit and leave me naked. Then she'd take me by the arms, and we'd step into the river. What happiness! I would've liked those swims to last forever.

Of course when it had rained, and the river was swollen, we couldn't swim. It happened once, and it was terrible: we had just gotten dressed and were eating lunch, and in an instant the river rose many feet. We lost almost all the clothes. The only thing Betzabé managed to save were the sheets. With amazing speed, she picked me up and put me in a tree. I held on with all my strength and felt the water running with such force that the tree trembled at its roots. She ran through the water, hanging from one limb to the next until she reached the bridge, and then proceeded to shout. Soon a bunch of Indians came, tied rope around their waists, and together lowered themselves to the tree where I was stranded. Of course we lost the pot and all the food and went home early, quite unsettled. Betzabé cried because she thought Miss María was going to let her go for having lost all the clothes, but quite the contrary: Miss María laughed heartily at our adventure and said that the clothes didn't matter.

The shop was open on Sundays too, because many people came from the countryside and nearby towns to buy chocolate. I rarely saw Helena and Miss María. I'd be sleeping in the early morning when they left, and be asleep again by the time they came back, late in the evening. Miss María had set up her room and a sort of living room at the front of the house, on the second floor. Helena and I slept in a room near

the back end of the patio, and Betzabé slept in an adjacent room. We went up to Miss María's rooms only if she called us, and that was very rare.

Soon after our arrival, Miss María became very ill. The doctor came many times a day, and we weren't allowed to go up to see her. Since the store was closed, Helena would spend the day with me, but we didn't play together like we had before. She didn't like the pig, or the hens, or climbing trees. For the first time we fought, though she was still protective: if she saw I was in danger or if I fell, she was always kind to me. It was around that time that new shipments of chocolate began to arrive from Bogotá. The shepherds and their pack mules would come, and they would sleep two or three days in our courtyard with everything they had brought—even the mules. They'd make huge meals and send us a big plate of food. At night they'd play guitar and sing, and, without telling Miss María, they'd let us ride the mules in circles around the patio. For us, it was like a wonderful party.

When Miss María reemerged, she was very thin and pale. She went to the store for only half the day, and gradually life returned to the way it had been before. That is, I was once again completely alone in the house. One Sunday Miss María came home crying and told Betzabé that the priest had insulted her in public because she was the only woman who went to church wearing a hat. The others wore a veil or a headscarf. The priest said that bad things, vice and sin, always came from the capital. The truth is, Miss María had left behind the veil forever, and indeed she fashioned extravagant hats for herself, and instead of wearing black dresses she wore light-colored ones.

Helena said Roberto brought many of those dresses and hats from Bogotá.

Still, Miss María came back furious the next time, but not crying. She decided to fight openly with the priest, just as he'd done with her. The priest had criticized her scandalous behavior. This is what he meant: after six in the afternoon, all the single men of Guateque gathered in the shop. Dr. Vargas, who wasn't yet married; Camacho, the engineer, who represented Singer sewing machines; a lawyer named Murillo; and others, depending on the day. They'd sit on the shop's benches and talk politics and women, recite poetry, sing, even criticize the priest. Sometimes their laughter was so loud that the priest, who lived across the square, couldn't sleep. These gatherings would last until nine or ten in the evening, an absolutely scandalous hour for a town like that one. And the fact that *she* was at the center of these meetings infuriated the priest even more. He decided to go to war with her.

One day, as a procession passed through the plaza, the priest left the group, jumped up onto the raised sidewalk, and entered the chocolate shop with a cross in his hand and a bucket of holy water, which he spilled on the floor, spouting prayers to drive the Devil out from that place. This was all the town's respectable families needed to shun Miss María completely. None of the women went back to buy chocolate. They'd send their maids or pay any Indian to do so for them, and it seems some even preferred to send for their chocolate from Tunja.

Helena, who stayed at the shop until they closed for the night, said that all the men were very respectful toward Miss María, that she was a gregarious and

cheerful host, and that the men always enjoyed themselves in her company. Of course Helena, who slept through most of these visits, doesn't remember much about what specifically was discussed, and anyway she was too young to judge.

Roberto went only on market days and preferred to come to the house after the shop had closed, which is why I never saw him again.

Then Miss María got sick again. Betzabé said it was a curse from the priest. The shop closed again, and the doctor came every day. We weren't allowed to go up to see her.

One morning Betzabé found us out on the patio and told us that Miss María was very ill and that she'd have to take care of her all day. In the meantime, Miss María had ordered us locked in the storage room, the only room with a key.

We went in without protesting, both of us, I imagine, thinking of those days when we lived in the room in Bogotá, the difference now being that the storage room had a small window, and we could see a small piece of the sky. The room held sacks of potatoes and raw cane sugar. With great patience, we tore open a sack of sugar and each ate a block. Naturally, when Betzabé came for us, we were doubled over with bellyaches and had already begun suffering from a bout of diarrhea that would last for many days.

The doctor who took care of Miss María said we should drink rice water and boiled pomegranate skin. When we were better, Betzabé told us Miss María wanted to see us and that we should go up.

I remember going up to the room as fast as we could. Miss María was in bed with her long hair

loose and wearing a blue blouse with white lace. In her arms she held a newborn baby.

When we saw the boy, we were paralyzed.

Helena took my hand and made me step back until we bumped into the wall across from the bed. There we stayed, hypnotized.

"The doctor brought me a gift," Miss María said, in an almost childlike voice. "Come closer. Come see him."

We didn't move. Helena squeezed my hand with all her strength. The baby started to cry, and we ran from the room. Without even having approached the bed, we went down the stairs, not uttering a word. I went straight to the patio and climbed into the oven. Helena did the same. We didn't speak; we didn't cry; we didn't play. We just nestled together in the oven, as if we were waiting for the hen to lay an egg, but that day there was no hen, and no egg, just the vision of that child in Miss María's arms.

Letter Number 6

Miss María stayed locked in her room with the baby for many days. I don't recall when we saw him again, just that one day Betzabé began emptying out the storage room, the same one we'd been locked in the night Miss María was sick. The room was in what could be called the center of the house, between the front courtyard and the back patio. Miss María, with the child in her arms, directed the work. She had the brick floor washed, and a kind of hay basket that served as a crib brought down from her bedroom. For furniture they left just a rocking chair and an old table on which they set out the child's only three shirts. The next morning, when Betzabé came to wake and dress me, she told me Miss María and Helena had gone back to the shop. That was the first time I asked for the baby. Betzabé told me he was in the storage room.

I jumped from the bed and ran there. I entered on tiptoe. The crib had been placed on a reed mat in the

middle of the room. I sat on the floor and studied the baby, body part by body part. His little ears were small, perfect; his face very white; his mouth thick lipped; his hair black; his feet long and fine; his hands tiny, and I couldn't pry open his fingers, which he pressed tightly. His mouth was slightly open, and it looked like he was laughing. Soon Betzabé came with a bottle; she picked him up, sat him on the rocking chair, and fed him. The child opened his eyes. They looked like Eduardo's eyes, black, enormous. I didn't tire of looking at him. I asked Betzabé what his name was, and she said Miss María had said he'd be called José sin Sal,* because she didn't plan on baptizing him. Helena and I called him the Boy.

My life changed: not the pig, not the hens and their eggs, not the trees and their fruit—nothing ever interested me as much as being with him. If he was awake, I was by his side, talking and playing with him. If he was asleep, I sat at the door, waiting for him to wake up. If he cried, I ran, calling for Betzabé to come with the bottle. Miss María had forbidden us to take him out of the room under any circumstances—she didn't want the neighbors to see him or hear him cry. Since he never got any fresh air or sun, every day he was whiter, more transparent, though he did grow and gain weight. They dressed him in a white cloth shirt with a long sash, which they called *fajero*, tied around the waist, and which Betzabé said couldn't be removed because his soul might escape through his belly

* This means "José Without Salt" and is a reference to the way children were baptized in Colombia back then—they'd rub a bit of salt on their foreheads.

button. I asked what a soul was, and she said it was everything one had inside.

Since he didn't wear diapers or underwear, he'd shit and piss in his crib, which was protected by a piece of red rubber. Betzabé showed me how to clean him with leaves we picked from the cow's tongue plant bordering the back patio, but at night, since I'd been sleeping, I'd usually find him covered in shit up to his hair.

Miss María went back to her life as before, that is, she left for the shop at six in the morning and came back late at night. She saw the child only on Saturdays, when Betzabé and I went to the river to wash clothes while she and Helena stayed home.

When the Boy became too big for the hay crib, it was switched out for one of the empty crates of chocolate. The crates were very deep, and I could barely reach to the bottom to clean it. When Betzabé wasn't watching, I'd stand on a rock and crawl into the crate; the Boy would laugh and shout with joy when I'd get in with him. Just like the pig, who was mine, whom no one looked after, I had the impression that no one took care of the Boy either, and that he was mine alone.

I would be brought to the shop only when there were celebrations in the square. One day Miss María told Betzabé to get me dressed and said we should go to the shop because there'd be fireworks. Of course we left the Boy alone, locked in the house, and when we arrived, the square, the church atrium, and the sidewalks were filled with people. I was lifted up on the shop's counter; the fireworks had begun, and you could hear people singing and playing guitar from every direction.

Then we heard a terrible, unfamiliar noise. People started running in all directions, most seeking refuge in the church, others running into the houses, the children climbing the trees. The shop, which stood on an upper part of the sidewalk, swarmed with people. The sound rumbled closer and closer. And then, from behind the church, appeared a horrific, black monster advancing toward the center of the plaza. Its enormous, wide-open eyes were yellowish and so bright they lit up half the plaza. People fell to their knees and began to pray and make the sign of the cross; a woman with two children threw them to the ground, then lay on top of them, sheltering them as a hen might protect her eggs. Some men advanced toward the square with large sticks in their hands. The beast stopped in the middle of the street and closed its eyes.

The first automobile had arrived in Guateque.

Bye.

Tonight the first human landed on the moon. Kisses.

Emma.
 Paris/69.

Letter Number 7

My dear Germán:

The arrival of the first automobile and the fireworks marked the beginning of a week of celebration in honor of the visit of the governor of Boyacá.

The festivities ended on Sunday with a great bullfight. It was the first time Helena and I would see a bullfight, and for the occasion Miss María had us wear new dresses made out of cheap green cloth, with red ribbing and tassels; she bought Betzabé a shawl fringed with silk and some new espadrilles.

We ate lunch at home. They dressed us, gave the child a bottle, and closed all the windows and doors. Then we went to the shop, leaving the Boy all alone.

The square had been closed off with bamboo fencing so the bulls wouldn't escape. Wooden bleachers had been set up in front of the church, along with a kind of throne covered in red cloth, for the governor. The windows and the balconies of the houses were decorated with garlands of paper flowers and the national flag.

The band, which had come from Guatavita, was

already assembled in front of the church. Little by little, at the corners of the square, the balconies began to fill with people, while Indians from all the neighboring villages crowded behind the makeshift fence.

Miss María, with Betzabé's help, set up a kind of barrier of empty chocolate boxes, so that people wouldn't come into the shop; this way both doors were blocked. We were placed on the benches inside the shop. Because the sidewalk was so high, it was as if we were on a balcony, with a view of the entire square. The fireworks began, and the band started to play "El Guatecano," the town's signature song.

Everyone shouted and applauded the musicians. The fireworks became more intense, and at the other end of the square the governor's delegation appeared. The Montejo girls proceeded to the front, with long white dresses, crowns of flowers, and white paper wings, like those of hens. Miss María said they were called angels and that their wings were for flying to heaven. In their hands they carried baskets of flower petals, which they scattered on the ground so the governor would know which way to walk. Behind the angels came the wives of the Murillos, the Montejos, the Bohórquezes, and the priest's sisters, and together the women carried a large banner strung with colorful ribbons. Painted on the banner was the Virgin of Chiquinquirá. A few soldiers walked behind her, and finally a large procession accompanied the governor: the husbands of the women who carried the banner; the mayor; the doctor; our friend Roberto, on a black horse; and beside him, the governor, on a large white horse. The priest awaited the delegation in front of the church; the band from Guatavita kept on playing

"El Guatecano," and the men took off their hats, some shouting in support of the Liberal party, others for the Conservative party.

The governor circled the square with his delegation, while the people tossed carnations and chanted his name. Helena and I jumped up and down with excitement. When the delegation approached the shop, Miss María hid behind one of the doors; it was in that moment that Helena and I saw that the governor, who was beside Roberto, was the same man who'd visited our room in San Cristóbal in Bogotá. When I saw him, I shouted: "Miss María, come, come see him. It's Eduardo's dad! Eduardo's dad! Eduardo's dad!"

In response, all we got were pinches on the legs that brought tears to our eyes. I'd never seen her so furious. She grabbed us by the arms and threw us to the floor. She took off one of her boots and started hitting us on the head, on the face, wherever she could.

"Bootlickers, bootlickers, bootlickers!"—it was the only word that came out of her mouth. When she tired of hitting us with her boot, she grabbed us by the pigtails and banged our heads against the wall. The blood ran down our legs and arms. Betzabé begged her to stop and shoved us beneath the counter, forbidding us to move. The two of them went back to the door. Meanwhile, the people kept on shouting hurrahs to the governor, the band played "El Guatecano" nonstop, and the fireworks exploded everywhere. When the bullfight began, Betzabé came for us and led us to the door. Miss María was at the other door, talking to a man who'd brought her a letter.

The first bull was grayish and drooled hungrily. It looked furious. The bullfighter was tall and skinny,

with tight white pants that were a little short; he had a hat in one hand, and in the other a red rag that he used to summon the bull; the fireworks continued, and the band started up "El Guatecano" again. Miss María turned and ordered us back behind the counter. The bullfight proceeded; we fell asleep on the floor.

I awoke to terrible screams; I felt like the boxes at the door had collapsed and the shop had filled with people—men, women, and children pursued by the bull. A man grabbed slabs of chocolate from the shelves and threw them against the bull's head. The bull, appearing calm, put its two front legs up on the counter. Then four men grabbed its tail and yanked him back. The bull gave two kicks and ran out behind a woman in a red dress. When Betzabé managed to get us out from behind the counter, she picked us up, then stood atop a box and pointed to the far end of the square. Everyone pointed and looked in the same direction. At first all I could see was a thick column of black smoke, but little by little I started to make out flames, rising high like the church towers. They were beautiful, all the reds, the yellows, the violets. The houses and the people had all but disappeared in the smoke that had engulfed part of the square. Everyone was screaming and running in all directions.

The bulls, too, ran, tossing people big and small, men and women, to the ground. People emerged from the houses with buckets, pots, and bottles, all rushing to the square's fountain to get water; men with lassos and sticks tried to corral the bulls, and the church bells clanged desperately. The flames kept rising. A very fat old woman with two large pots, one at each hip, was flung in the air by a bull's horns. She landed

in the middle of the fountain, nearly emptying it of water with her splash. Other men ran around with green branches and sacks of dirt. The entire town was in disarray, with everyone trying to put out the fire. The wind blew in the direction of the blaze, fanning the flames from one property to another. It was just us left in the shop, and I couldn't take my eyes off the fire. One of the Montejos appeared and told Miss María that it had started at the hospital—one of the fireworks had landed there, setting the hay roof alight. The fifty patients who were inside had died in the flames. The director, who'd been at the bullfight, had left them locked inside; none of them could escape.

Fortunately the blaze was in the opposite direction from our house, that is, in the lower part of town. The flames leaped from one street to the next, while the women rested against the outer wall of the church, praying and wailing, and the men hauled along branches the size of trees and dirt. The fire burned for three days, reducing the entire lower part of town to ashes. The dead and the injured, victims of both the fire and the bulls, numbered more than a hundred; for many days the sky stayed a dark shade of gray, almost black, and the smell of smoke and fire had penetrated every house and every room and could be detected in the clothes, in the food, in the water. I remember that fire as the most beautiful and extraordinary spectacle of my childhood. For a long time I thought it had all been part of the festivities to honor the governor.

Paris, October/69

Letter Number 8

My dear Germán:

After the celebrations and the fire, everything went back to normal. There was only one new thing in our lives, and that was that Miss María had taken to beating us. Since we'd both cry no matter whom she was hitting, she decided it didn't matter who'd committed the infraction, she'd just hit us both.

One day she returned to the house in a very bad mood. The Boy was crying because he needed his bottle, and she decided that was the day to give him a bath. When he was totally naked, she raised him up very high and, staring him in the face, said: "This son of a bitch is starting to look like Eduardo!" Then Helena said it would have been better to keep Eduardo than to go and have a new one made. Helena hadn't finished her sentence when Miss María started beating her with an open hand. Before she was finished with Helena, I ran to hide in the oven, the only place where she couldn't get me.

She didn't go to the shop the next day but stayed locked in her room. Betzabé brought her lunch, but she didn't want to eat. When it was beginning to get dark, she called for us to come up to her room. Everything was messy, and in the middle were two open trunks; she'd started packing up clothes. We're going back to Bogotá, she announced, and accused us of being the cause of her sorrows. "Without you, I'd have another life. I never would've come to this miserable town. I could be far away and have everything in the world. But with you always underfoot, I'm tied like an animal. That's it, tied like a cow. But listen: I promise you this situation can't last much longer. I swear it, and you'll remember my words—the first chance I get, I'm going to give you to someone. I don't care who it is. Now get out of here and don't let me see you again or I'll beat you with sticks."

We descended the stairs hand in hand and went straight to the Boy's room. We sat next to his basket and started to cry. He watched us with big open eyes, and though he made no sound, it was as if he could feel our pain: tears streamed down his cheeks. He scrunched up his mouth and looked out with eyes of a bottomless sadness.

The preparations for the trip took many days. Since Miss María didn't go to the shop and was always home, she'd scream at us or hit us for any small thing. A *yes* or a *no* could be enough. Those were very long, very sad days.

Toribio arrived the night before our trip with the horses and three more Indians. Everyone gathered out on the patio that night, singing and playing the

guitar. Toribio loved me a lot, and he brought me a gift, a basket full of plums. All of us slept in the same room, atop reed mats, with the Boy, as always, in his basket. It was still dark when they woke me. Betzabé had already made breakfast, and Miss María was bathing the Boy, something she almost never did, since the only one who washed his face and cleaned off his shit was me. Helena helped me get dressed while Betzabé put away the four frayed outfits that were all the Boy had to wear. While I drank sugar-cane water and ate a piece of dark bread, the two of them wrapped the Boy in a large blanket and fastened him with a kind of white sash. Betzabé went down-stairs to braid her pigtails and get a kerchief. Miss María, who was very nervous, yelled at her to hurry up, because we were going to be late. Betzabé picked up the Boy and the little basket with his clothes, then took my hand, and we left, nearly running. When we got outside, the horses were braying and I could hear Toribio singing from the patio.

Betzabé told me along the way that we were headed to the river, but it was so dark I couldn't see the path, and there was as much wind as there had been the day of the fire. When we got to the bridge, which I knew well, instead of going down to the pool where we always washed our clothes, she went straight, and we crossed along a narrow path, covered by large trees, that ran alongside the river. At the end of that trail we saw a large white house, not made of hay but with a thatched roof. Betzabé told me to wait for her next to a tree bent over the river. I followed her with my eyes, saw how she walked on tiptoe, lightly, lightly, as if she wanted to fly. She approached the large door,

setting down the basket and then the Boy right up against it. When she covered his little head with a blanket, I realized that we'd gone there to abandon him. I wanted to scream but couldn't. My legs shook, and like a spring I bounded toward the door. Betzabé managed to grab me by one leg, and I threw myself to the ground and began to bang my head against it. I felt like I was drowning. Betzabé struggled to lift me up, but I clutched the weeds, contorting like a worm. She begged me to get up, telling me urgently, in a near whisper, not to make a sound and to run before anyone woke up. I kept hold of the weeds, my face pressed to the ground; I think I learned then, in that one moment, what injustice is, and that a child of four is already capable of feeling that they no longer want to live, that they should be swallowed by the earth's bowels. That day remains, without a doubt, the cruelest of my life.

I didn't cry, because tears wouldn't have been enough. I didn't scream, because my sense of outrage was stronger than my voice. Betzabé, kneeling beside me, continued begging me to get up. The Boy started to cry, and I felt his whimpers from the depths of the earth. I looked up and saw that Betzabé's face was bathed in tears. My resistance crumbled. I let her take my hand, and she lifted me up in her arms. Breathlessly, like crazy, she started to run. I felt she was holding me tight, tight against her, and her tears fell behind my ears and ran down my neck. She stopped only when we reached the bridge. I don't remember the rest. I recall only that Toribio placed me on the mule that would take us to Bogotá. Helena tells me that I couldn't speak for three days. Miss María was worried that I'd been left mute. The return trip was

just like the outbound trip, except that this time Betzabé came with us, and instead of Burro, the mule we rode walked very fast. I don't remember details because surely by then I didn't care about life anymore. The first trip represented the abandonment of Eduardo, and the second the abandonment of the Boy.

Your Highness, I'm sad because this letter didn't come out the way I would've hoped, but I don't feel able to try again.

Kisses to the whole family, and don't forget me.

Emma
 Paris, October/69

Letter Number 9

My dear Germán:

 In Bogotá we moved into a miserable hotel next to the Sabana station. We had a single room for all of us, a tin roof, and a brick floor. It was in the back courtyard, next to the bathroom. Not only were we freezing to death, but also it was so dark that during the day we had to light candles in order to see. Miss María went out to the street every day and came back only at night. She'd leave us ten cents so the three of us could eat, barely enough to buy sugarcane water and bread. We spent the days in the room or, when there was a little sun, in the courtyard. Betzabé cried all day; she said she wanted to go back to Guateque. She was honestly terrified of going out into the streets. She arranged for two old ladies to bring us the bread and the sugarcane water because the store was three blocks away, and she was afraid to venture that far in such a large city. In the same hotel, there was a woman from Tunja who lived with a policeman. She had two daughters who were a little older than we

were. She was very nice and was the only one who said anything to us. When she found out that we ate only bread and sugarcane water, she told Betzabé how bad that was, that we were going to get worms; it was very little nourishment, she said. For herself and her daughters, she made stew, which was more nutritious.

As they were discussing how much it cost to make, the two old ladies arrived with the bread and the sugarcane water. I'm not sure how they concluded that if we gave our ten cents, and the old ladies their ten cents, along with the policeman's wife's ten cents, we could make one big stew, with meat, potatoes and broad beans. There was only one problem—how to get a big enough pot, since according to the policeman's wife, with all that money we could make enough stew so that each of us could have two plates, one at midday and another to warm up at night. Betzabé said she'd saved five cents, which she'd put down to buy the pot; the old ladies gave one cent each, and the policeman's wife said that since she had the stove, she wouldn't put in for the pot. There was a street market behind the train station, and they all decided to go see how much a large clay pot cost. It was twenty cents, and all we had were Betzabé's five and two from the old ladies, so seven in all. Betzabé spoke with Miss María, and after saying we were going to ruin her, she decided to give us five cents toward the pot. In the morning we gave them the great news— we had twelve cents. The policeman's wife said okay, she would put in the three cents she had reserved for soap. In the first courtyard lived a woman who was a little bit black and her son, who was older and worked

on the train. He was the one who carried coal for the machines. He was always covered in soot, and we were afraid to look at him. The policeman's wife decided to speak to them and see if they wanted to go in on the stew. They agreed, and that same day they went out to buy the pot.

We ate our first stew the following day. It was a real celebration. Everyone in the back courtyard placed the big pot in the sink, wrapped in rags, and we all crowded around it, each with our plate. The stew was thickened with dough, and there was a good piece of meat for each of us, plus lots of potatoes and Brussels sprouts. The policeman's wife was the one who did the shopping and served us all. Naturally they all became friends, and Betzabé became very good friends with the coal worker. Miss María never ate with us; she usually wasn't there, but if she was she stayed in the room with the door closed. She wasn't friends with anyone; she would just say hello and keep walking. She said the others were vulgar, but she thought it was fine that we ate stew every day.

We'd been there about a month, and those meals were our only entertainment. The day's second serving of stew, this one without meat, would be warmed up around six in the evening. From that moment, whoever came would sit on the patio and await the arrival of the pot. When it appeared, we'd all shout with joy. It was an afternoon just like this one when the policeman, the neighbor's husband, appeared. Doña Inés—that's what we called her—was starting to serve, hunched over a plate with a big spoon in her hand. We all had our eyes fixed on the pot. It was the boom-boom of the shots that made us look up. The

policeman, with a revolver in his hand, had just fired two shots at his wife. She fell like a stone onto the pot of stew. The pot cracked into a thousand pieces, and everyone ran. Betzabé threw us toward the door of our room, and the three of us locked it from the inside.

The woman didn't die, but we never had stew again. It would've been impossible to gather up the money to buy a new pot, and Mrs. María forbade us to have any contact with anyone in the residence. A few days later, she announced that we'd been placed in charge of the chocolate shop in a town called Fusa-gasugá.

We made one part of the trip by train and the rest on horseback, but the route wasn't anything like the road to Guateque. It was more mountainous and very cold. The Indians who came with us drank fermented *chicha* the whole way, and Toribio wasn't there to take care of us anymore. We arrived in Fusagasugá under a terrible downpour, and no one would tell us where the shop was. It was dark by the time we found it. It was in the same building as the theater, a huge house with a two-story facade. There was a huge wooden door that was the entrance to the theater, and also a shop where they sold tickets, a large storage room with doors that led to the street but which were always closed. The last store was the chocolate shop. Like the one in Guateque, it also had two doors. At the back, behind a shelf, there was a door that led to the interior of the house, and to the right of the door was a stair-case leading up to the second floor. The first two rooms, directly above the shop, were reserved for us; the six other rooms along the corridor were closed and

were filled with light fixtures and furniture belonging to the theater. These rooms were rarely opened; after all, a theater company or ballet passed through town only two or three times a year. Down below was a big yard, with benches rooted to the ground so the audiences couldn't move them. The yard was uncovered; if it rained, there was no show. To the left was a very tall, thick wall, and the house extended to the right. Along the corridor were two more rooms that served as storage for boxes of chocolate. All the doors and windows were behind iron bars. You entered this part of the house through a small door that was also behind iron bars, and the only ones who could go in were the owners of the house, the Castañedas, two elderly sisters who took care of their younger brother, who was crazy, violently crazy. We never went inside, but the old house servant told Betzabé that the sisters had the crazy brother tied up in chains in an interior courtyard, but that they loved him very much and wouldn't let him be taken to an asylum. The old sisters never came out; I saw one of them only once. The only people who went in and out were the maid and an old lawyer, who served as administrator of the house and the theater. At the end of the yard with the benches was the stage, a giant box made of boards and covered with zinc. Behind the stage were two staircases, one on either side, that led to another large patio, where there were large wooden dressing rooms.

Those rooms were my paradise.

There were dresses in every color, long ones, short ones; capes, hoods, crowns, swords, fans, beads, boots, gloves, hats, wigs of every color, and a thousand things I'd never seen before in my life and that

neither Betzabé nor Helena knew the names of or what purpose they served. When we arrived, there was a Spanish company that came to rehearse every day. I didn't understand anything they said, but watching them walk, enter, leave, run, and talk was enough fun for me, and I learned from them to play at theater. I dressed up a thousand different ways. I'd get onstage and invent all kinds of stories. I often imagined I was talking to the Boy or Eduardo, or sometimes to the two of them. Helena and I would sometimes pretend that she was Mrs. María and I was Betzabé. We played at making stew, and at Doña Inés falling over the pot. One day we wanted to re-enact the fire in Guateque, but Betzabé took away our matches and hit us.

Mrs. María decided to send Helena to the school run by the Mojicas, so they could teach her to read, but they wouldn't take me because I was too little. The kitchen was in the same yard where the dressing rooms were. I liked this house a lot, the theater most of all, and the only thing I wasn't allowed to do was go out to the street or bother Mrs. María at the shop. When there were parties in the theater, we would be locked in the upstairs rooms, but otherwise we were free to roam. One day there was a very big party, and a giant piece of furniture was left on the stage, along with some drawers filled with rolls of paper dotted with tiny holes. I unrolled them and spread them over the benches in the yard, and I skipped beneath them. Then the lawyer showed up. When he saw me, he put both of his hands to his head and started shouting. Mrs. María, Betzabé, the old maid—everyone rushed to the yard.

"A mess, Mrs. María, a mess! Look what this scoundrel has done with all the piano rolls!"

Everyone began to roll up the scrolls. When I saw that Mrs. María was starting to take off her boot, I knew she was going to hit me, so I darted toward the door and ran out into the street. I emerged into a large square with a market; I looked in all directions and didn't see Mrs. María, so I decided to stroll through the market, and an old woman gave me a mango. Across the square was a church, and at the entrance I saw the priest surrounded by many children. I got closer, and he was asking all of them what their names were.

"And you . . ." He sighed. "This poor little one is completely cross-eyed. Tell me, what's your name?"

"Nené."

"Nené? That's not a name."

"Yes, I'm Nené."

"Who's your mother?"

"The chocolate shop."

They all laughed, but I started to cry. The priest asked the others if they knew me, and they all said no, so the priest asked me again who my mother was.

"The chocolate shop."

The priest took me by the hand and walked me to the shop. Mrs. María told him about the piano rolls, and the priest went with us to the theater and up to the stage, opened the large piece of furniture, put back in the rolls, and music began to play. I stood still, as if paralyzed. I examined the piece of furniture from top to bottom and couldn't see any musicians. I asked if the musicians were locked inside, and everyone laughed. The priest explained patiently that the

music came out of those tiny holes in the paper. The good priest taught me my favorite game from childhood. I learned how to operate that player piano perfectly, so carefully that the lawyer didn't forbid me touching it. The priest became very friendly with Mrs. María. He'd come often to the shop to speak with her, and then they'd come into the theater to look for me and he'd play pretend with me. One Sunday we went on a lovely little trip to the river, all of us—the priest, Mrs. María, Betzabé, and us. We had our lunch by the river and picked lots of flowers.

In the mornings it was Betzabé who opened the shop, and she waited for Mrs. María to come down and replace her. One day when Mrs. María went, the shop was closed, and Betzabé was nowhere to be found. We asked all the neighbors, but no one had seen her. We went to her room and saw that all her clothes were also gone. We all began to cry. Mrs. María didn't open the shop, and the three of us went to the church to tell the priest that Betzabé had disappeared. Mrs. María cried desperately, and the priest promised he would ask around town if anyone had seen her. I remember looking for her for days among the theater dresses, beneath the benches, inside the player piano. I'd get up onstage and shout: "Betzabé, come! Don't leave us, Betzabé, we're very sad, come back, come back, Betzabé!" My shouts were useless. Betzabé never returned. Later we heard that she'd been seen with some cattle drivers roaming the plains on the way to Bogotá.

Paris, October/69.

Letter Number 10

My dear Germán:

With Betzabé gone, our life changed completely. Our make-believe in the theater, my concerts on the player piano, Helena's school—all of it was abandoned. Mrs. María decided that the two of us had to take over for Betzabé, because she had to take care of the shop.

They taught me to sweep, and I assure you the broom was larger than I was (I'd just turned five and Helena six and a half); they taught me to peel potatoes, carry water, take out the trash and the ashes from the stove, wash pots and plates, help unpack boxes of chocolate, clean floors. Helena made the beds and helped in the shop on market days. Mrs. María washed the clothes at night and prepared the food for the next day so that all we'd have to do was light the stove and heat it up. I remember that Helena did all that while standing on a crate because the top of the stove was taller than she was.

One night they sent me down to the backyard alone, to get the water bucket, and I wept with fright.

I went on tiptoe, my back against the wall, barely breathing, aware of the slightest sound. I'd crossed the theater and was passing by the first of the wooden dressing rooms where all the costumes were kept when I felt two giant hands press against my waist and lift me up in the air. Just like when we'd abandoned the Boy, I was struck dumb, unable to make a sound. I felt something like a rock in my throat, drowning me. At first I couldn't see anything either, but then I felt the hands set me down on the ground again, and it was at that moment that I was face-to-face with the lunatic: his bulging eyes, his thick black beard, his open, tooth-less mouth. He was completely naked. As he placed me very carefully on the ground, he knelt beside me and started to kiss my face. I felt the hair of his beard on my mouth, my nose, my eyes, my ears. I tried to hit him and kick him, but his large hands were stronger than my feet or my arms. Then I saw a light appear at the door to the yard; it was the two elderly sisters, looking for him with a lamp. As soon as he saw them, he sprang to his feet. I was still on the ground. They came closer very slowly, calling him in a sweet voice, while he stood over me, watching me intently. When he saw that they were close, he grabbed his dick with both hands and peed on me, spraying me from head to toe, as if I were a plant. When he was finished, he turned to them without saying a word, wearing a great big smile.

One of the old ladies picked me up, took me to Mrs. María, and told her she shouldn't let us go out alone in such a big house, and certainly not at such a late hour. If they hadn't come out, who knows what might have happened. Helena undressed me, and they

washed me thoroughly, even my head, with the old lady helping even as she chastised Mrs. María.

Mrs. María got very bored in Fusagasugá. Just as in the other places, she had not a single girlfriend, no one she saw regularly; nor did she have, as she'd had in Guateque, that cluster of men who came to chat with her at the shop. The only man who visited us from time to time was the Dominican priest with whom we'd taken the outing. Without Betzabé, life had become very difficult for all of us. One day Helena was lighting the coal iron—or, rather, the iron was lit and she had placed it, uncovered, on the floor. She climbed onto a box to take down the bellows. I don't know exactly what happened, but the fact is she fell off the box and landed atop the iron. Poor thing, I felt so bad for her! A complete impression of the iron was imprinted in the middle of her ass. You could see it on her red skin; I remember that she ran shrieking all over the theater. She was so sick and threw up so much that Mrs. María never let her do anything more in the house or at the shop. That's when I discovered that Mrs. María had a real preference for Helena. She repeated the same phrases all the time: the prettiest, the one I love the most, I would've preferred this to happen to Emma, my poor little darling. I'd never seen her so affectionate; she seemed genuinely anguished by Helena, lying facedown day and night with that terrible bruise because she couldn't lie on her back or sit up. Of course I couldn't do the work of the two of us. One night Helena had a high fever, and Mrs. María started to cry and told us she couldn't take it anymore, that it was impossible to go on, that she was going to write to Bogotá and quit

the chocolate shop, that she was a miserable soul without a man at her side to help her make it through life. She told us again that we were the cause of all her grief, because without us she'd be living like a queen.

A few days later a man arrived from Bogotá, sent by the chocolate company, to go over the paperwork and look for someone to take over Mrs. María's franchise. He became very good friends with her. He was a young man, very tall, suntanned, with pretty green eyes. He was very kind to us and always brought us candy. He gave us the first dolls we'd ever owned in our lives, rag dolls with kinky black hair. Helena's was dressed in red, mine in pink, and we adored them. Mr. Suescún—that was his name—helped Mrs. María take out the trunks and deal with the aggravation of packing. We knew from experience that Mrs. María would get into a very bad mood when it was time to pack up, but Mr. Suescún helped us a lot. He took charge of finding the Indians with the horses for the trip back to Bogotá, and he said he'd come with us. Mrs. María was beaming.

You must think it strange that I can tell you in such detail and with such precision what happened so long ago. I agree with you, that a child of five who leads a normal life wouldn't be able to recount his childhood with this level of accuracy. But we, Helena and I, remember it as if it were today, and I can't explain why. Nothing got by us, not the gestures, not the words, not the noises, not the colors. Everything was clear for us.

They woke us at dawn on the day of the trip. For some reason we never knew, they decided we wouldn't ride on horseback but instead be carried by men. They

bought two chairs of woven vine, made an awning for them, and tied each to the back of an Indian. Then they picked us up and sat us there.

Mrs. María and Mr. Suescún went ahead; behind them went two Indians with the pack mules, and last, the two Indians that carried us. They were given a basket with food for the two of us. The two Indians were drunk. Each had a large calabash of *chicha*. The one carrying Helena, whose face was covered in pimples, had diarrhea and would take off his pants, squat, and shit while making horrible noises. Mine would stand beside him, dying of laughter, telling him: "Drink more *chicha*, buddy. Only *chicha* is good for the runs."

Mrs. María and Mr. Suescún continued on ahead of us, and when we got to the plateau we didn't see them anymore. The Indians were relaxed, telling stories we couldn't understand. The one with diarrhea was getting worse, until suddenly he sat on a rock and said he couldn't go any farther. The other one, mine, told him that if we didn't hurry we'd miss the train, that Mrs. María had said she'd wait for us at the station. They gave each of us bread and a banana and kept drinking *chicha*. They stopped at a farmhouse to fill up their empty calabashes and dawdled there, chatting with other Indians. When they came out, they couldn't walk anymore; they were so drunk they zigzagged. Then they started to fight. One took out a knife, but the one with diarrhea said, "I can't kill you because I have to go take a shit."

He dropped his pants and knelt down; the other one put his knife away and started to sing. It was getting dark; Helena began to cry and shout for Mrs.

María. I started shouting with her, until we got tired and fell asleep. We woke up as the Indians were leaving us at the train station. It's curious that neither of us recalls the name of the town. We remember the station, the hotel, and the church, but not a single street. By that point, the train had left a long time ago, and Mrs. María and Mr. Suescún had also left, without waiting for us. The Indians asked the man at the station and others if they'd seen a young woman in a dress and a gray hat, accompanied by a man from Bogotá. Everyone had seen them board the train. Little by little the people surrounded us. Helena and I looked at each other, and we had the same thought. Then at the same moment we began to cry, a single sentence emerging from both of our mouths:

"She's left us."

Our hands and our heads came together, and our weeping subsided. The number of people around us kept growing; they all asked us the same thing:

"What's your name?"

"What's your mother's name?"

"What's your father's name?"

"Where are you coming from?"

"Where were you headed?"

Nothing interested us. We answered no one. We saw them without seeing them, heard them without hearing them. In that moment, only Helena and I knew the true shape of our lives. Someone went to get the priest from the church, and he came, fat, big bellied, with a nose like a red ball, and squatted beside us, patting our cheeks and asking us:

"What's your name?"

"What's your mother's name?"

"What's your father's name?"

"Where are you coming from?"

"Where were you headed?"

We couldn't say a word. By then the Indians who'd brought us had disappeared. No one saw them again, and little by little the people dispersed until we were alone with the priest and a soldier or policeman. They took us by the hand and led us to the hotel. The owner was a very serious woman wearing the dress of the Carmelite order, her white hair pulled back in a bun. The soldier stayed with us in the courtyard, and the priest took the owner aside. Helena understood that the priest was saying: "Keep them here. Surely the mother will come to pick them up on tomorrow's train. I'll come tomorrow after mass."

The hotel's dining room had glass doors that faced the street. They sat us at the table, and we watched once more as the people gathered, crowding against the doors, some pressing their faces to the glass so they could see us more closely. Everyone argued and pointed.

The woman made us serve the food and then she sat between us, cutting our meat and our potatoes into tiny pieces, but neither of us wanted to eat. Some people in the dining room approached our table, begging us to eat and asking us:

"What's your name?"

"What's your mother's name?"

"What's your father's name?"

"Where are you coming from?"

"Where were you headed?"

They took us to a room with two beds and laid us down, one on each. When the woman left and locked

the door, Helena got out of her bed and lay down in mine. We embraced each other fiercely and fell asleep.

When the priest and the soldier came back the next morning, the woman from the hotel was brushing our hair. We still wouldn't speak. They took us to the station. We heard the train whistle and saw it enter the station. When people started to disembark, the soldier picked up Helena, and the priest lifted me, and they held us very high, pointing at all the people passing by. Once all the passengers had gotten off the train, the crowds began to thin. They put us back on the ground, disconsolate, and returned us to the hotel, where we spent the next day in bed. I think we slept, but I can't remember, because neither of us spoke. Another train came that afternoon, and the priest and the soldier repeated the same scene at the station. We knew she wasn't coming back for us. Three days passed this way. Each of these three days, morning and afternoon, the same scene at the train station was repeated. The priest seemed worried and commiserated with the soldier and the woman from the hotel. On the fourth day they didn't take us to the station. The priest came with two nuns wearing black and white. One was old with glasses and the other was very young and happy; she picked us up, kissed us, rubbed our heads tenderly:

"What's your name?"

"What's your mother's name?"

"What's your father's name?"

"Where are you coming from?"

"Where were you headed?"

They took us to a convent out in the countryside. We entered a large courtyard with many flowers and

a statue of a priest. As soon as we arrived a throng of nuns appeared from all over, and they surrounded us:

"What's your name?"

"What's your mother's name?"

"What's your father's name?"

"Where are you coming from?"

"Where were you headed?"

These questions were repeated in every tone of voice, loud, some less loud, sharp, shrill, authoritarian, affectionate. Then, abruptly, there was complete silence; all we saw around us was a wall of black nun's habits, pushed together one against the other. I heard Helena's voice, which felt very strong to me, and it said: "My name is Helena Reyes, and my little sister is called Emma Reyes."

Helena took my hand and, pushing with her head through the nuns' dresses, brought me to the edge of the garden, where there was a cage filled with birds. The nuns were still, frozen, and they followed us only with their eyes. As we approached the cage, far from the nuns, Helena said in a low voice: "If you talk about Mrs. María, I'll hit you."

And that silence lasted twenty years; neither in public nor in private did I ever say her name again, or speak of the years we'd spent with her, or of Guateque or Eduardo, the Boy or Betzabé. Our life began at the convent, and neither of us ever betrayed that secret.

A thousand memories and kisses. Write.

Emma.

Paris, November 1969.

Letter Number 11

My dear Germán:

There were no girls in that convent. It was a convent where they made nuns. There were some very young ones, but they were all novitiates, and we weren't allowed to be with them. We weren't allowed beyond the first courtyard, where the entrance and the visitors' rooms were. Next to the entrance were two rooms, one where the doorkeeper slept, a very old, pigeon-toed lady who talked to herself all day; in the second room, full of furniture and packages, they arranged a bed for the two of us, because Helena didn't want me to sleep alone. In the doorkeeper's room was a large table, where food was left for us whenever the nuns brought food for the doorkeeper.

In the mornings we played alone and helped the old doorkeeper water the plants. The courtyard was enormous, with many flowers and large trees, plus the birdcage; we'd spend hours talking to the birds. The young nun from the hotel, the one we called our friend, would come in the afternoon. Sometimes a

group of novitiates would come and stand at the door to the second courtyard. They'd watch us and smile, but they couldn't talk to us. The first thing the young nun taught us was to play cross, which she called making the sign of the holy cross. Every finger had a name, she said, but only the ones on your hands; the ones on your feet have no name. Like the Boy, we thought. To play cross you had to close your whole hand and leave up the finger called the Thumb. With Thumb, we had to make three crosses, as if they were two sticks crossed one over the other. The first cross is made on the forehead, the second on the mouth, with your mouth closed, and the third in the center of your chest. Then you had to quickly open all your fingers and with your hand stretched out completely, make one large cross with the tips of all your fingers, first in the middle of your forehead, then the middle of your chest, then on your left shoulder, then on your right shoulder, and finish by giving the nail of Thumb a tiny kiss, always with your mouth closed. I enjoyed that game a lot, because I was always making mistakes and all my crosses would get mixed up. Sometimes I started on my chest and finished at my forehead. Or started with my mouth, and instead of kissing Thumb I'd kiss the pinkie, because I felt sorry for it because it was so small. The nun would get furious and make me start over a thousand times.

Another day she told us the story of a boy named Jesus. This boy's mother was also called María. They were very poor and traveled by burro, just as we had when we went to Guateque. But this Baby Jesus had three fathers. One that lived with his mother, whose name was José and who was a carpenter; another who

was old and had a beard and who lived in the sky among the clouds. This father was very rich; according to the nun, he owned the entire world, all the little birds, all the trees, all the rivers, all the flowers, the mountains, the stars—everything was his. The third father was named the Holy Spirit and he wasn't a man but a dove that flew all the time. But since the mother lived only with the poor father, they didn't even have a house to live in, and when Baby Jesus was born he had to be born in the house of a burro and a cow. But the old father, the rich one who lived in the sky, sent a star to some friends of his, who were also rich and were called Reyes, *kings*, just like us. Those men came to visit Baby Jesus at the house of the cow and the burro, and they brought him so many gifts of gold and jewels that he wasn't poor anymore, but rich. I asked her to take us to where that child was, but she said he wasn't on the earth anymore, that he'd gone to live with his rich dad who was in the clouds, but if we were good and obedient, we'd see him in the sky.

We spent hours looking at the sky to see if we could see him. Helena told me one day that if we could climb one of the larger trees, she was sure we'd see him, that we couldn't see him because we were small. We waited for the old doorkeeper to fall asleep after lunch, and we climbed the tree. When the nuns came, we were holding on to the highest branches, so high up we couldn't hear what they were saying. We couldn't get down. The nuns ran in all directions and gestured for us to wait. They brought some ladders, which they tied together, and called a man dressed as a soldier, who climbed up and brought us down. The old woman whom they called Mother Superior hit us

on the head and legs, but when we said we'd climbed up the tree because we wanted to see Baby Jesus in the sky, they all started laughing, threw themselves at us, and covered us in kisses on our face, our head, our hands. The old doorkeeper wept and said, "They're two little angels, two little angels . . ."

We were in that convent only a few days. One morning, as we were waking up, a new nun came to take our measurements. She took long pieces of thick gray cloth and made us two very ugly dresses. They were long like those of the novitiates, with a high collar, long sleeves, and many pleats. They were so odd looking that I hardly recognized Helena anymore, and Helena hardly recognized me. They also bought us espadrilles, which were nice indeed. They combed our hair back into pigtails so tight I could barely close my eyes. The Mother Superior brought some pieces of small white cloth stuck to a brown necklace that she called scapulars. She put them around our necks and said we should never take them off, that they were so that people would know we were daughters of the Virgin Mary and of God. When the nuns left, I asked Helena who had told the Mother Superior we were daughters of Mrs. María and Mr. God. Helena didn't answer and gave me a slap on the mouth.

A while later, all the nuns came back. One brought a basket covered with a white handkerchief. One by one they started to kiss us and make crosses in the air with their open hands. Our friend and the Mother Superior took us by the hand. The young one took the basket, and we left the convent. As soon as we were out on the street, we started to cry. We went directly to the priest we already knew. The Mother

EMMA REYES

Superior spoke with him as they strolled through the garden. When the train whistle blew, they took us by the hand and we left, running toward the station. When we saw the train, we called out in earnest, shrieking, "No! No! No!"—but we weren't sure what we were saying *no* to. I held on to the priest's legs, not wanting to get on the train, but finally they forced us to board. When we saw that the nuns were coming with us, we calmed down a bit. They told us to kiss the priest's hand, and then the train left. No one spoke during the trip. Helena and I pressed tightly up against each other, and I could see great anguish in her face. Her eyes had gotten bigger, and she opened and closed her mouth as if she were out of breath. The Mother Superior looked at her watch and told the young nun that it was time to eat. They opened the basket; there were hard-boiled eggs, potatoes, pieces of hen. We ate only a banana. When we got to Bogotá, we took a horse carriage like the one we'd taken with Mrs. María when we left the room in San Cristóbal. In the buggy we started to cry all over again, perhaps because we were thinking of her.

The buggy stopped on a narrow street, in front of a large door. A little piece of wire stuck out through a tiny hole; the Mother Superior pulled it, and a bell rang. We heard the sounds of chains, keys, sticks, and door knockers, and finally the door opened. "Good morning, Sisters. The Mother Superior is waiting for you. Come in, come in; this way."

I couldn't see anything. Everything was a fearsome darkness.

Mother Dolores Castañeda was tall, so pale she was almost transparent, with very large hands and

66

extraordinary tenderness and generosity. She leaned forward and asked our names and our dad's name and our mom's name.

"We don't know."

"Helenita, you, who are so pretty and are already such a big girl . . . tell me, what's your mom like? Do you remember what she was called? And your dad?"

We both began to weep.

"Tell us, Mother. You haven't been able to figure out who the men were that abandoned them?"

"No."

"And not where they came from?"

"No. Mother, the priest has been to all the markets to speak with the Indians. At mass on Sunday, he has asked all the faithful that if they know something, they should tell him, but until now we haven't been able to find out anything. If the girls remembered anything, they could help us, but as you see, anytime anyone asks them, they start crying, or fall silent. I promise you, Mother, both we and the priest will keep asking, and if we find out anything, we'll let you know right away."

Mother Dolores Castañeda looked very concerned. "Mother, I insist and I beg you not to give up. It's not because we're interested in finding or knowing who the parents of these two children are. What I'm interested in is knowing whether or not they've been baptized, whether they are legitimate children or daughters of sin. You can imagine that we can't have, beneath the roof of this holy house, two girls who were conceived in sin. We have the obligation before God to save their souls. I'll have to ask the bishop what we can do."

If I can recall this conversation with such accuracy, it's because we heard the same one, with the same seriousness, repeated for years. Every now and then they would bring up this issue again, either because we had a visit from the bishop, or because Superior General was coming from Rome, or because Holy Week or Christmas was approaching. Every time someone important from church visited us, they'd take us to the sitting room and we'd be subjected to the same questions, with the same arguments.

The two mother superiors went on discussing how to save our souls, until a bell rang, and we were told to kiss the Mother Superior and say good-bye. The old one and the young one made the cross over us, then bowed their heads and left without a word. Again we heard the keys and the chains. When the door opened, a ray of sunlight swept across the sitting room. On the floor you could see the shadows of the nuns as they departed.

The door closed behind them, separating us from the world for almost fifteen years.

A big hug for everyone.
Emma.
Paris, January 1970.

Letter Number 12

My dear Germán:

Three locks, two large padlocks, one chain, and two thick wooden bars secured the first door that separated us from the rest of the world. The second had only one lock and one padlock; between the second and the third was a vestibule onto which the doors to the sitting rooms opened. When the Mother Superior was certain all the doors were properly locked, she took our hands and led us through an interior staircase to the chapel. In the center of the great altar was a large statue of the Virgin, holding the Child up high. She made us kneel before it, and behind us, in a loud voice, asked him to bless us, accept us as his daughters, and forgive our sins. On our way out she dipped her hand into a cup of holy water and made crosses on our foreheads. We went back down the stairs and through a small door, emerging into the first courtyard, dedicated to María Auxilia-dora. In the center, atop a white column, was the Virgin, with the Child in her arms. She looked like the

one in the chapel. The courtyard was full of plants and flowers, surrounded by wide, brick-lined corridors and large columns. Only one person lived in this courtyard, and her name was Miss Carmelita. The Mother Superior brought us to her, told her our story, how we'd been abandoned, and expressed once more her profound concern, that she had to know whether we'd been born in sin.

"You know very well that the only thing we require here is that every girl we accept must present her proof of baptism. About these girls, we know nothing. We have to ask God to illuminate us and help us find a solution, a light, a sign."

As the Mother Superior spoke, Miss Carmelita looked us up and down, touching our arms, our backs, our waists through our heavy dresses.

"Poor things, they're so skinny . . . You can tell they haven't been taken care of. The older one is very pretty. The little one, have you noticed? Her eyes are crossed. And what are we going to do with them? They're too small; they won't be able to work . . ."

"That's another problem, Carmelita. What will we have them do if they're so small . . . ? Perhaps we could begin by putting them in the kitchen, so they can help with the cleaning, carrying water. And they'll be taken care of there."

As they spoke, Helena and I didn't take our eyes off Miss Carmelita. We'd never seen such a fat person. Think of the fattest person you've ever seen and double her four times.

The Mother Superior left us with Carmelita and disappeared through a door in the back. Carmelita asked us if we knew how to sing. With great difficulty,

she rose from her chair, and when she did, a kind of sucking sound was heard between her and the chair, three times—*pluc pluc pluc*. We erupted with laughter, and she also smiled.

Miss Carmelita was not a nun. She'd made up a black habit with a black hat and veil, so she looked like a nun, but she belonged to another community. She spent the day in a giant leather chair and was so fat she couldn't enter the chapel and had to listen to mass from outside the door. When the priest gave communion, he took the communion wafer to where she sat.

She would be an important part of our life. Little by little I'll explain how and why, but for now I'm going to tell you her story, which all the girls knew. Miss Carmelita (no one knew her surname) belonged to one of the wealthiest and most distinguished families of Medellín. At fifteen she had a very handsome, very rich boyfriend who'd proposed to her, saying they'd marry within three years. But under one condition: he'd marry Carmelita only if she put on weight, since it seems she was so thin they called her "Wire."

Her parents had her seen by the best physicians in Medellín, and Carmelita didn't put on weight. They traveled with her to Bogotá, new doctor, new treatments, and still Carmelita didn't put on weight. They were informed that there was a famous German doctor in Panama, and they set out with Carmelita, arriving in Panama, where the doctor promised he'd have her gaining weight within three months. But it was as if someone had given her the evil eye: Carmelita didn't put on weight. From Panama to Cali, from Cali to Quito; now there were only six months before

the three years were up, and Carmelita was still wiry and thin. Frantic, they returned to Medellín and made a promise to the Virgin of Chiquinquirá if she performed the miracle of making their daughter gain weight. She and her family were at the height of desperation. Every day Carmelita was more in love with her boyfriend, and every day her boyfriend was firmer in his decision: Carmelita puts on weight or I won't marry her.

It was precisely on Palm Sunday, as they were leaving mass, that they ran into a friend of the family named Paquita. She told them that a wise man had arrived in Pácora, a witch doctor who cured everything, everything, everything . . . Hope brightened the eyes of the entire family, and the next morning they left for Pácora. The witch doctor stared deeply into Carmelita's eyes for a long time; he made her stick out her tongue. He struck her three times in the back and after many long seconds of silence declared that she was suffering from two illnesses: worms and the evil eye. For the evil eye he gave her an assortment of herbs accompanied by various prayers, and for the worms, two large bottles of a brownish-violet liquid. "You'll see, madam, that your daughter will be fat in only thirty days. At the moment the full moon appears, the evil spirits will leave her. As far as the worms, within a week she'll start to expel them. Examine the young girl's deposits and you'll be convinced of my words."

No one ever knew if the evil spirits ever left Carmelita's body, but as far as the worms, they came out by the dozens, and Carmelita put on weight and then more weight, at such speed that when the boyfriend

came to see her, he didn't recognize her, and since she kept gaining weight, he said he didn't want her anymore because they'd switched her for someone else. When the family went back to the wizard to find out why the girl kept getting fatter, he was forced to confess that he'd made a mistake. He'd given her medicine used to fatten thin cows. And that was how Carmelita abandoned the world and locked herself in a convent. Since she was still in love with her boyfriend, she couldn't be a nun, but she gave her entire fortune to the convent so they would let her live there.

When we got to the convent, Miss Carmelita was already very old, and whenever the girls and the nuns noticed her losing weight, they'd spend the day praying that she'd gain it back. They said she'd been carrying an illness for a few years, something very serious that they called "the Belt," whose primary symptom was a black stain across your waist. When the stain connected, that is, when the two sides met, you died. For this reason Miss Carmelita spent the whole day eating; in the kitchen there was a girl who spent her day dedicated solely to the preparation of soups, chocolate, pastries, purees. She took Miss Carmelita something to eat every hour, more or less, to keep the two sides of the black stain from meeting.

Carmelita lived in the only two rooms that faced the Virgin's courtyard. The smaller of the rooms had a giant bed that had been made especially for her. Like the beds of the nuns, it was enclosed in a white cloth canopy. In this room was also a large bowl, a jar, and a bucket. In the second room, two large leather trunks with gold-plated locks. The girls said those trunks were filled with gold coins and precious

jewels. There was a large piano positioned at an angle. Carmelita adored music. She composed all the music we sang in the chapel, and each year for the Mother Superior's birthday she wrote a choral piece. Despite the fact that her hands were just two pudgy balls, to us she played beautifully.

Still, she had a harsh character and treated us very badly. Without leaving her two rooms, she knew everything that went on in the convent before even the nuns did. She knew everyone's name and each of our stories. The Mother Superior discussed every problem, serious or not, with her. We had the right to see her, one on one, only on Saturday and Sunday afternoons. We'd find her seated in a leather chair, a table with wheels next to her, where she ate, wrote, and composed her music. From that chair and that table she directed, as if by magic, each of our fates. She was as fanatical with her sympathies as with her antipathies, but in general she saw us all as poor miserable ants. In her every gesture you could see the intense disdain she felt for us. Nor were the nuns immune: she divided them into two classes, those from good families and the others. The only one she considered to be at her level was the Mother Superior. They had a profound and genuine friendship. Like her, the Mother Superior played piano and the harmonium, and that in itself was a point of deep connection. Now you'll understand why the Mother Superior, after introducing us to the Virgin, introduced us to Miss Carmelita, and why the Mother Superior needed her approval, to unload her conscience for having violated two of the regulations of the convent: first the absolute prohibition on

accepting girls without proof of baptism, and second the prohibition on accepting girls younger than ten. The house was not an orphanage but one that took in poor girls, with or without families, in order to teach them to work. It cost ten pesos a month to stay there, but they were flexible on this point: there were many of us who couldn't pay. But what we produced with our labor was all for the nuns, and I can assure you our work was worth thousands of pesos.

I find it terribly boring to speak to you of the organization, but I have to do it, little by little, so you can have a true and accurate sense of our life. It was Sor María Ramírez who came to get us from Miss Carmelita's, who in just a few minutes brought Sor María up to speed with our names and what they knew about our lives. Sor María took us to the dormitory of Baby Jesus, which was for the youngest girls. The door, like all the doors in the house, was kept locked. Our beds had been set up next to the canopied bed of Sor María. She made us take off the gray dresses the other nuns had made for us; she opened a large dresser and had us try on some old smocks that had belonged to other girls. The smocks were the mandatory uniform, with long pleats and long sleeves, a high collar, and a fabric of tiny white and blue squares. She had us take off our espadrilles, saying that everyone except the oldest nuns had to go barefoot. Since we were used to that, it didn't bother us. She told us to ask her for whatever we needed and tell her everything that happened to us, since she was the one who'd be in charge of us. Helena said she didn't let me sleep alone, that one bed was enough for the

two of us, that she was afraid she'd lose me while she slept. Sor María calmed her down, saying she would help take care of me.

We left the bedroom, which she locked once more, and went to the second courtyard. This one was three times the size of the Virgin's courtyard, but there wasn't a single flower or tree. It was all brick, with corridors and columns on all sides like the first, but all the doors were closed, and the glass on the windows was painted white so you couldn't see anything. The silence was complete, and we couldn't see anyone. I asked where the other girls were, and she said they were in the work-rooms. Helena asked if there were many girls.

"Many, many," said Sor María.

"Many? Like how many?" I asked.

"Many . . . Like one hundred fifty."

"And how many is one hundred fifty?"

At that moment one of the bells rang behind us, so powerfully that the two of us jumped off the ground. A minute later the doors on the second floor opened, and girls streamed out from all the doors, a throng coming down the stairs. They looked more like a herd of cattle. The stairs, all the stairs, had doors that were permanently locked, but they were more like gates that didn't go all the way to the ceiling, and you could see who was on the other side. Sor María ran to the door, took a large key chain from her belt, and opened the gate. She was barely able to take the key from the lock; all at once, the girls rushed through, and Sor María managed to lean against the wall to avoid being trampled. Helena and I were lost in a world of dresses, legs, bare feet, and hands attached to unknown arms; the tiny blue and white squares

marched before our eyes at vertiginous speed. I yelled for Helena; a fat girl, perhaps the only one who noticed me, picked me up and propped me against one of the columns, perhaps so I wouldn't get squeezed by the avalanche. When it passed, Helena and I were on opposite ends of the courtyard. Instinctively, we ran each to the other and embraced tearfully.

"Emma, my doll," Helena shouted. "I'll never let go of your hand again! If we get lost among all these girls, what are we going to do?"

"If you get lost, I'll find you," said Sor María, who had once more shut the gate to the staircase.

The girls had all disappeared through the far door; you could hear them yelling. Sor María told us to go to them, but we trembled with fear.

"Don't be scared. I won't leave you alone," she said.

There were two nuns, one on either side of the door to the third courtyard. One was Sor Teresa Carvajal, who limped and took care of the kitchen. The other was Sor Inés Zorrilla, who was in charge of laundry. With them were two big girls, each with a large basket; in one were pieces of cut raw cane sugar, and in the other, pieces of black bread. Each girl was given a piece of sugar and a piece of bread. Sor María told them our names. The girls seemed calm. They were divided into groups, and each girl had her lump of sugar and piece of bread. With just one hand we held the bread and the sugar; with the other Helena and I gripped each other's hands firmly. We ate, eyes peeled, scanning the courtyard, so we could see what the other girls were doing. Some talked, others strolled, the youngest ran. That third courtyard was as big as the second, but the ground was made of rocks, and

one part of the courtyard was covered, so we could take refuge there if it rained during recess. Again the bell rang, and Helena shot up like a spring. She pulled me by the arm, and we got behind the door, for fear that the girls were going to overrun us again. Sor María came to get us out of there and told us we had to go get in line. The lines were organized according to height, two by two. They didn't have to measure us: we were the smallest, and we stood first in line.

We suffered a great deal those first days; everything was strange for us, and everything the nuns said was incomprehensible. The girls were scary, and we didn't talk to any of them; nor did they approach us. When someone had something to say to us or to show us, they didn't call us by our names. Instead they called us "New Girls." At recess they played all kinds of games, but we didn't know how to play any of them. In the chapel, the others prayed and sang and we didn't know what that was or what it was for. The nuns spoke of sin, the Devil, heaven, hell, saving our souls, gaining indulgences, repenting our sins, thanking the Virgin for the grace of allowing us in her home—none of this had any meaning for us, and it was in those days that we came to know profound solitude and the complete absence of affection.

The nuns seemed genuinely concerned. We were afraid they'd abandon us because we were sinful. What was sin? And if the Devil takes sinful girls, who was the Devil?

A big hug and kiss for the whole family.
Emma.

Letter Number 13

My dear Germán:

We came from a world so distant from that of the convent that our adjustment was very slow and difficult. We'd follow instructions, listen, but we understood very little of anything going on around us. That inability to adapt and understand kept us from communicating with our peers, for whom we felt more fear than love. We had everything to learn, and they took advantage of our ignorance to be cruel to us. No one called us by our names; we were known simply as "the New Girls." "The New Girls should wash the dishes, the New Girls broke this, the New Girls stole that . . ." It's hardly worth mentioning the ones who'd step on our toes as they passed by, or pinch us, or who simply stuck out their tongues.

It had been many days since our arrival when one day, at recess, Sor Teresa sent Helena to sweep the bakery and help clean up after a sack of flour had ripped. I was alone, standing with my back against a wall, waiting for her. A group of girls played together,

spinning in a circle, all holding hands. I'm not sure how I found myself suddenly in the middle, and they began to close in around me while the girls shouted, "Dirty little girl, shitty, dirty little girl!"

The circle closed, and they threw me to the floor and took off the only pair of underwear I owned. Of course it was dirty—it was the same underwear Mrs. María had dressed me in when we left Fusagasugá. One of the girls, a very fat one, cross-eyed like me, hung my underwear on a broomstick. They marched along, the broomstick held high, forming a long procession through the courtyards, shouting in a chorus: "The New Girl's dirty underwear! The New Girl's dirt—" Helena managed to hear this last bit, and she stormed out, crazed, running and calling for me. I was hiding in one of the bathroom stalls, trembling with fear. Fortunately the bell rang, and recess was over. Sor Teresa asked what that rag on the broom was, and, in one voice, they cried: "The New Girl's dirty underwear!" Sor Teresa was furious because it was immodest to leave a girl without underwear.

That same day they ordered Sor María to make me two new pairs.

The rules were very harsh. Every hour of every day was dedicated to a specific activity, predetermined and unchanging. At five thirty in the morning they rang the bell to wake us. As we sat on our beds, our first act of the morning was to offer God and the Virgin Mary our each and every deed, so that they, in their infinite mercy, might forgive our sins, save us from dying in mortal sin, and give us light and strength to march only along the path of righteousness, that we might be worthy of joining them in the

Kingdom of Heaven . . . Lord! So many words that held no meaning for us! Helena and I would look at each other, shrug our shoulders, and laugh.

Get dressed, make the bed, use the *toilette.* That was the hardest thing, peeing, because we had only half an hour. Peeing was a *tour de force.* When they opened the dorm room doors, we ran like colts, as fast as we could, to be the first ones to the five toilets. No one respected anyone; they threw themselves on the stairs, one against the other, to get ahead. Naturally the ones who got there last never got to use the *toilette.* They spent the half hour in line, and it was almost comic to watch them jumping on one foot, "chicken leg," as we called it, to hold it in while they waited their turn. Of course in my case, I was scared all the time and couldn't wait, so I'd end up peeing on the floor in front of everybody. They called me dirty, filthy, a wild Indian. The word "Indian" was considered an insult.

At six they rang the bell once, signaling it was time to line up for chapel. We went in two by two, and as we passed in front of the altar in the middle of the chapel, we had to genuflect, touching the floor with our right knee, while we made the sign of the cross. Always behind us, standing like a soldier, was Sor Teresa, the angriest, cruelest, and most inhumane of all the nuns. She was in charge of the laundry and the sewing workshop and was the nurse and the custodian of lines, and so it was she who had to worry about our physical appearance. She noticed if we'd brushed our hair or not, if we had clean feet (all of us, with the exception of one of the older girls, went barefoot), and if our smock, the one we wore to mass,

was dirty, torn, or poorly ironed. She made sure that our genuflection was done correctly; if one of the girls didn't bend her knee until it touched the floor, she pulled her up by her pigtails and made her repeat the gesture three or four times. In the chapel, as in the dining hall, our places were fixed: the smaller you were, the closer you were to the altar. The nuns each had a seat with a kneeler, placed strategically in the aisles, so they could monitor all our movements.

The prayers we recited were all in Latin, and we learned them by memory, without anyone ever explaining their meaning. The important thing was to recite them with devotion and in the strong, or sweetly supplicant, or dramatic tone that they had taught us.

Every day, without exception, a priest came to say mass. Usually it was the same one. When we arrived, the priest was Father Bacaus—that's how we pronounced it—but he was German. Long and skinny like a nail, always dirty with unkempt hair, his body gave off a strong stench of iodine, like menthol mixed with incense and burnt wax. He was the only man, and the only person from the outside world, whom we had the right to see. Father Bacaus would say mass while pacing like a hurricane, rushing from one side of the altar to the other, so that when he turned for the *Dominus vobiscum* or to give the benediction, the smaller girls, those of us nearest to the altar, would feel a gust of wind as his cloak and tunic flew through the air. Not only did he say the mass at great speed, he was also so clumsy that not a day passed when he didn't knock over a flower vase or a candelabra or a missal, which would fall from the lectern, or the chalice, which would spill over the altar. The sole of one

of his shoes was always coming off, and without exception he'd stumble over the rug every time he came in. We'd watch as, with both hands holding the chalice, he'd fall forward, almost touching the floor, only to straighten up at the last moment and regain his balance. Naturally we'd die laughing. He performed his genuflections touching the floor with his knee so violently that the altar and the crowns of the saints would rattle for a few seconds. The nuns had asked many times that he be replaced, but the response was always that there was a shortage of priests.

On Sundays he'd explain the Gospels to us in a Hispanicized German, speaking just as rapidly as he moved.

After mass he'd offer the blessing with the large crucifix; when he used the incense burner, he'd swing it nearly up to the ceiling. We'd close our eyes, lower our head, awaiting the blow.

During the benediction the girls who were part of the chorus would get up and stand around the harmonium that the Mother Superior, Sor Dolores, played. The songs were also in Latin. The singing was what I enjoyed the most, and I couldn't resist looking over my shoulder to watch them. Naturally Sor Teresa pinched my arm all over. Since I was the smallest, my spot was next to her so she could teach me what to do.

When the harmonium sounded I couldn't hold back my tears; they rolled down my cheeks and fell onto my hands, which I was supposed to keep clasped together on the pew. That sound always reminded me of the player piano in the theater in Fusagasugá, and it seemed like that had been a happier time because I

was free and did what I wanted. The convent seemed terribly sad to me, and the girls were of no interest to me.

We left the chapel at seven, changed out of the smocks we wore for mass and into the ones we wore for work, and lined up to go to the dining hall. For breakfast they gave each of us a cup of water with raw cane sugar, which was usually cold, and a roll of dark bread. Once we were finished we went off to start working, or, to be more specific, to clean the house.

On the first of the month they read aloud the list of jobs for the entire month. The girls who'd behaved well all month were rewarded with the easiest ones: sweeping a hallway or one of the four staircases, cleaning the banisters, the windows, sweeping the embroidery room or the dormitories. The girls who embroidered well were also given easy jobs, so they wouldn't hurt their hands. The most coveted assignment was in the sacristy or the chapel—only the older girls got that work, on the condition of impeccable behavior. The jobs that served as punishment were in the kitchen, washing enormous pots of food, cleaning out the trash cans, scrubbing the courtyards and hallways on hands and knees. Worst of all, the task reserved for the most disobedient girls, was cleaning the bathrooms. As I was telling you, there were only five for nearly two hundred people, who had to use them at the same time, on the same schedule. I can't describe that spectacle to you. The bathrooms were very small, with no running water. There were holes in the cement floor, and stuck to the cement were square boxes with a hole in the middle. Most of the girls were from the countryside and

carried on the way they did out in the country. The nuns, surely out of modesty, did nothing to educate us in these matters, so that, aside from excrement, there were piles of rags of all colors. I assure you it was the most disgusting thing I've seen in my life. And every day, of course, I had to handle those rags and that filth and wash it all with lots of water and, with a broom, make all that muck slide into the drain of the nearest courtyard; then I had to fill buckets with hot water and Creolin soap to disinfect the bathrooms and the courtyard. The housework, with the exception of the bathrooms, had to be finished precisely at eight, which was when we went to the workshops. There were four workshops; the most important, and the one that brought in the most money for the convent, was the embroidery workshop. The second, dedicated to tailoring and sewing on machines, was, like the embroidery workshop, on the second floor. On the lower floor, distributed among various courtyards were the workshops for mending and knitting clothes; and in the fourth courtyard, next to the backyard, the laundry and ironing rooms.

Our lives were dedicated to two overarching goals, which went hand in hand: to work as much as possible in order to earn our keep and, according to the nuns, to save our souls, protecting us from the sins of the world. But for us, saving our souls had a price: we had to work ten hours a day. Our age, our abilities—neither mattered; there was always work for all of us. We never saw the people we were doing the work for; it was the nuns who spoke with them. We knew some clients, because the nuns talked about them, saying

they were very demanding and examined every job in great detail. There was a Mrs. Sierra, who commissioned embroidered sheets and tablecloths, but the best customers were some women they called the Turks. They brought piece after piece of the most beautiful linens so we could make tablecloths and sheets. The jobs done for the Turks were the most important. They brought pictures of what they wanted, always very complicated; for the tablecloths the embroidery would cover every last centimeter of the linen. They also commissioned silk underwear and sleeping gowns with stitching down to the feet. For the elegant weddings of Bogotá, Cali, and Medellín, they'd commission trousseaus, and layettes for the important baptisms. Other churches and convents commissioned chasubles, cloaks, vestments, robes, and garments for the altar. One of the convent's specialties was gold brocade. It's a delicate task managing the gold thread, and very few have hands that are skilled enough. For many, the gold turns black in their hands. The nuns called this "the evil humors"; and a girl who had them couldn't touch gold, even if she knew how to handle it, because it would lose its shine. The army sent us lots of work for flags and crests for celebrations and marches; every regiment needed a banner with the name of the battalion embroidered in gold, along with its corresponding insignias. The Catholic associations of Saint Vincent, Saint Anthony, the Carmelites, the Daughters of the Heart of Jesus, the Daughters of the Heart of Mary, etc., etc., all of them commissioned banners for their processions. We also got work from the presidential residence.

For you, Germán, this may all seem quite clear, but for us, who never saw hide nor hair of the people who commissioned the work, who knew nothing about anything, this mix of work, the Turks, the infantry officials, the Daughters of the Heart of Mary, the sash of the president of the republic, the bishop's miter, the Gentleman Diplomat's embroidered pajamas . . . all of this was hot air, along with the prayers in Latin and the constant refrain, like background music: "in the world," "for the world," "it comes from the world"—because nothing that happened in the convent happened in the real world. No. Everything was "in the world" except for us. We had no right to ask for explanations of anything. The world was sin, period. That's why we prayed, in the morning when we started work, and at night. We said countless Hail Marys on behalf of our sinful clients who offered us this labor, so we could eat and save our souls.

Naturally this relentless focus on the same objective had all but convinced us that we were the most fortunate and happiest people alive. That's why it never occurred to us to protest, or to demand justice. Our lives had no future, our only ambition being to go from the convent directly to heaven, untouched by the world. They were waiting for us in heaven, with open arms and celestial songs, the saints, the angels, the archangels, and the cherubs, who, among the clouds, would lead us for eternity to the kingdom of God and the Virgin Mary.

Our only enemy was the Devil. We knew everything about him. In fact, we knew more about the Devil than about God: all his tricks, all the means he

utilized to make us fall into sin. We also knew hell down to its last corner, knew it so intimately we felt we could navigate it with our eyes closed. We knew all about the pots of scalding hot oil in which the Devil placed the naked sinners, only to take them out with their skin in tatters. We knew he had enormous iron pitchforks that he used to move souls in the fire pits, stirring them as if they were pieces of meat in a pot. We knew he had millions of chains that he used to tie up souls, in order to drag them along trails and mountains seeded with bits of glass and thorns. The Devil was large, agile; he could leap many feet and was always dressed in red or phosphorescent green. His hair always pointed up, and he also had horns like a bull. His yellow eyes shot flames, and his nails were long and green. He had big teeth like a burro, and when he opened his mouth there was the awful smell of sulfur. Hell was full of animals we'd never heard of—lions, serpents, caimans, and many others, large, small, but all terrible, all shut away in dark caves. If you had sinned with your eyes, the Devil would remove them with hot needles; and if you had sinned with your mouth, he'd cut your tongue into pieces. There was nothing we didn't know about the Devil, and of course they never let us forget him. If we threw out strands of thread, they told us the Devil was going to seize them and torture us with them in hell; if we tossed out something to eat, they said the same. If we didn't confess and took communion while in sin, our bodies would be dotted with filthy sores that the Devil would fill with green, red, and yellow worms to devour us.

Sister Dolores Castañeda was the Mother Superior. Tall, elegant, with white, nearly translucent skin and

beautiful hands that she always held crossed over her chest, clutching the Christ that hung from a chain around her neck, she was the one who played the harmonium in the chapel. She never hit us, never yelled, never humiliated us. On her lips was always a beatific smile, full of generosity. We adored her. Every evening (before going to chapel for the day's last prayers) this angelic creature gave us a sort of speech or presentation, which we called "the Director's Good Night."

With perfect posture, an elegant stride, and an eternal smile, she'd emerge from her room and walk along the corridor, where we waited for her, in lines of six. "Good evening, Mother Superior," we sang out in a chorus. She'd raise her beautiful white hand and bless us, then wait until we were perfectly silent before beginning her talk. If, during the day, one or many of the girls had committed some grave error, she'd speak about it, reprimanding us even as she gave us advice and guided us with an extraordinary generosity. If the following day was the feast of some important saint, Saint Joseph, Saint Anthony, Saint Ignatius, or Saint John Bosco, then she'd talk to us about those saints or tell us anecdotes about their lives; if it was the month of Mary, she'd talk to us about the Virgin; if Christmas was coming, she'd tell us how the Baby Jesus was born; if it was Holy Week, the passion of Christ. But when there was nothing going on, which was most of the year, then she'd talk to us about her favorite subject: the Devil.

What a prodigious imagination! For twenty minutes each time, she'd talk to us about him, never repeating herself; she'd always find new examples, new forms and colors to help us imagine what hell was

like. Every day she revealed new kinds of torture, each worse than the others. Without a doubt, the Devil was her favorite character and role, the one that allowed her great dramatic skills to achieve the sublime. Her mouth would twist in a thousand directions as she imitated the most macabre moans and bellows; her eyes, usually so sweet, jumped from their orbits, darting in all directions; her voice took on every nuance; her pauses were dramatic; her lovely hands morphed into beastly instruments of torture. We listened without blinking, barely breathing, our hearts racing from fright. I remember one night, during one of her famous portrayals of the Devil and hell, when precisely at the story's grisliest moment, the two cats who were always locked in the bakery escaped, and chased each other at great speed, scurrying madly between our legs. Of course no one saw the cats or even thought of them. We all thought of the Devil and panicked; in an avalanche we threw ourselves toward the Mother Superior, who fell to the ground, without her veil or her crucifix, her sleeves shredded because each of us had made a desperate grab at anything with which to defend ourselves against the Devil. She was holiness for us, purity itself, and the only way to save ourselves was to take a piece of her. All of this commotion was accompanied by shrieks, shouts, and snatches of various prayers, and when the other nuns came to save her from beneath our legs, the poor thing was more dead than alive. For three days we didn't see her.

And now—don't judge me. If you think it's enough to have ideas, I'd say if one doesn't know how to express them so they're comprehensible, it's the same as

not having them at all. My head is like a room full of old junk where you don't know what's there or what state it's in. If I didn't have the prize of traveling to Russia with you lovelies to look forward to, I swear I wouldn't go on. But don't get sad, because the Devil takes advantage of sad people, too.

Kisses to the Gabrieluchas and a big hug.
Emma.
Paris 2/28/70

Letter Number 14

My dear Germán:

Each workshop was led by a nun who specialized in the task, and Sor Carmelita,* the only saint I've ever met, led the embroidery workshop. She had the hands of an angel, and everything she did was perfect. There was simply no problem she couldn't solve. She was the one who drew the designs and copied them onto the fabric, getting everything ready for us to begin the embroidery. She designed monograms for sheets, handkerchiefs, and pajamas of extraordinary beauty and elegance. If one of us made a mistake while embroidering, or tore one of the pieces of fabric—which happened many times—she was the one who would fix it. She knew more than three hundred kinds of stitches, which she applied at will, depending on the shapes of the drawings and the quality of the fabric. We'd get the drawing that went

* Sor Carmelita is different from Miss Carmelita, who appears earlier.

with each job, and since we didn't know how to read, she'd draw in blue the shape of each stitch she wanted us to sew. Many years later I took over almost everything for her, because the poor thing had gone nearly blind.

Sor Trinidad, a native of Antioquia, strong as a bull and with an almost inhuman cruelty and coldness, led the dressmaking workshop. She was the one who treated us worst of all, because we were daughters of the street, because we were poor, because we were stupid, despicable, pitiful beings. But she was an extraordinary dressmaker, and of course, like all of them, she had her favorites.

Sor Teresa, the most ordinary of the nuns, the most vulgar, with the soul of an executioner, supervised the laundry. The work there was endless, and after embroidery, it was the workshop that made the most money. A hundred fifty bags of laundry arrived each week, to be washed, ironed, and mended. There was a lot of very delicate clothes from the church or tablecloths that had to be starched and ironed to perfection. Sor Teresa was responsible for everything except for the ironing, where the nun I loved most, Sor María Ramírez, was in charge. The coal irons came in every size, some very heavy and large, some so small they looked like toys. There were always more than twenty irons sitting atop a cement table, all of them hot, ready to be used.

The tailor shop was in the second courtyard; Sor Inés, poor thing, was in charge, but we never took her seriously. We considered her our equal, and so no one obeyed her. The nuns themselves didn't respect her either; it seems she came from a very poor family, in

Boyacá, and the class prejudices among the nuns were terribly pronounced.

Sor Honorina was our entertainment. She was Italian, spoke awful Spanish, and was very old, but she was as agile and jittery as a spinning top. She was always agitated and had a bad temper, but she was full of extraordinary generosity and kindness. The first thing that made us laugh was her name, Honorina, then her language and her buffoonery—there was something of a Neapolitan clown in her. She directed the kitchen and the bakery, with fifteen girls permanently under her supervision. She was the only one who went out into the world, to shop in the market, accompanied by two old women who'd been in the convent for thirty years, and who'd spent each of those thirty years in the kitchen. They weren't thought to be like us; they didn't follow the rules and never participated in anything. They had a room to themselves above the bakery. They never talked to the girls.

You understand that, given the infinite variety of jobs, the nuns always had a way of getting us to work for them. No matter how stupid you might be, you were always good for something, even if it was just blowing on the irons, untangling thread, undoing stitches, threading needles, folding clothes, or separating dirty clothes. I remember a girl of indeterminate age, with Down syndrome, who spent ten years at the convent making balls of soap for ten hours a day. Two kinds of soap were used for washing clothes—a black soap called mud soap and a yellow one called pine soap. You had to mix the two and make balls of them, the size of a hand.

The first job they gave me was in the laundry, sweeping away the mountains of foam that gathered at the drains and blocked the water. For many months I spent ten hours a day going from one drain to the other with my tiny broom, not being allowed to sit for even a moment. The laundry employed the strongest girls on the one hand, and the most intellectually limited on the other. My second job, a step up, was in the embroidery shop. I spent the day threading needles. They'd say to me only "ten," "six," "eight," "three to thread," "little worm," "soul," "tracks." Each represented a specific kind of thread. I loved this job. I spent the time in a tiny seat at a large table, all the threads arranged impeccably, with a thousand needles of varying thickness poking out from a small blue pillow. For each thread, there was a particular needle, whether thicker or thinner. When I'd prick my finger with the needles and bleed, Sor Carmelita would tell me that my soul could escape through the hole, which frightened me terribly.

An embroiderer began by learning how to remove a needle. The delicate sewing of frills, particularly the smooth kind or moiré, outlined with gold or silver thread, couldn't be done by folding it on a canvas because it would get wrinkled; you had to spread it out to its natural size. Of course the eyes and the arms of the embroiderers couldn't reach farther than forty centimeters from the edge of the fabric. So to work on the center, you had to stand up and have another girl take out the needle. Boxes were placed beneath the canvas, and the one who took out the needle would lie completely horizontal, with her head directly beneath the

section to be embroidered, and in that position she'd receive the needle and wait for the embroiderer to indicate where the needle had to be returned. She signaled this by making a hole with another, slightly larger needle. It was exhausting work. When it was time to go, after five or six hours of this, I'd walk out like the drunks from the cantinas. That was my third job. It was my bad luck that I got so good at it that I wouldn't get pricked when the needle was returned. I'd learned to embroider in reverse, which represented a huge step forward in the work, such that for many years I never managed to get switched to another job. Naturally this contributed greatly to my eyes, already crossed from birth, getting even worse. No one knew which direction I was looking in.

After much discussion, the nuns decided to remedy my cross-eye and give me glasses. Glasses made by them, of course. It was the Mother Superior herself who made them. They were very simple, two black cardboard squares, very strong, tied together with wire. In the middle of each piece of cardboard was a tiny hole made with a needle. If I wanted to see, I had to look through the hole. If I didn't, I couldn't see anything.

It was a marvelous remedy. I was happy, because I had felt different from the other girls. For four years I tolerated those cardboard squares on my nose, but I doubt any ophthalmologist could have cured me much better.

Talking was strictly prohibited during working hours, except conversation about the work itself, which was permitted in a very low voice. For every piece of

fabric there was a girl in charge of the sewing, and she gave verbal instructions to her helpers.

The only thing that was permitted was praying aloud. Anyone could lead a prayer of the rosary, or a few requiems for the souls in purgatory, or a holy hour. And because we were always in debt to God, we tried to pray as much as we could during work. In that sense, Miss Carmelita had the most important role in our lives. Because none of us had money, all the gifts we offered, which were many, we offered in the form of prayers.

For the Mother Superior's birthday, a set of prayers. For the birthday of the chaplain, another set. To send to the Pope in Rome on Saint Peter's day, another. To the Virgin during the month of Mary, to Baby Jesus at Christmas, to our patron saint, John Bosco, to Mother Carolina Mioletti, general director of our community, to the bishop on the day of his celebration, to our friends on their birthdays. In other words, not a month passed without having to gift another set of prayers. Between us, I doubt there were more than ten girls who knew how to read; the rest of us were illiterate.

And Miss Carmelita was the only person who could help us. Because she had no obligations in the convent, she was in charge of her own time. I don't know when this came about, but the fact is that she was secretary and accountant for all of us.

We went to her at recess, in alphabetical order, when we had to make a gift. She wouldn't allow more than one of us at a time. Next to her, always on the tabletop, lay large accounting books, and in a tin box she kept the colored papers on which she'd write our prayers or

our letters to the saints or to Baby Jesus at Christmas. The formula for these bouquets of prayers was this:

> I, Emma Reyes
>
> Offer to the Sister Superior (or whomever) with great affection and respect the following spiritual bouquet in honor of her birthday.

Masses	(Here the quantity)
Communions	50
Hours of silence	20
Rosaries	20
Requiems for dead relatives	100
Mortifications	25
Acts of humility	25

The bouquets for Baby Jesus at Christmas were different, because we had to make him clothes so he wouldn't come into the world naked. These were written like this:

> I, Emma Reyes
>
> Offer the following items to Baby Jesus for his birth:
>
> Six wool shirts to be paid with 6 masses
> Twelve diapers to be paid with 12 communions
> A little hat made of wool (we were free to choose the quantity, the material, and the different types of clothing)
> Two pairs of tiny socks with pink and blue pom-poms to be paid with 20 acts of humility . . .

And so on and so on until we'd completed the trousseau.

Each set of prayers was signed "Your humble" or "Your unworthy daughter, Emma Reyes." When it was completed, she'd fold it in fours and give it to us to give to the intended party. Then she took one of the large books where our names were written, and she'd note down the quantities, add them up, and ask us how much we were going to pay her.

"Well, I've paid ten masses."

"Ten masses? But that's not possible. You owe three hundred masses already. At that rate, you'll never finish paying. And what else?"

"Well, fifteen rosaries."

"Good."

"And one hundred requiems . . . And that's it."

"What do you mean that's it?"

"And the hours of silence and the acts of humility . . ."

And that's when the awful discussions began. She'd insult us, treating us like dishonest thieves. Not paying God what we owed him was the worst kind of robbery we could commit. "Next time if you don't pay what you owe me"—it was no longer God who was owed, it was she—"I won't take care of your accounting anymore!" But she didn't forget the next time; on the contrary, she was the one who pushed us to give more when it was time to offer prayers, calling us greedy, faithless, and selfish. She was never at a loss for words to insult us.

There was a girl from Tolima who'd been at the convent for twenty-two years and was so deep in debt to Miss Carmelita that there was an accounting book

just for her. It was the Mother Superior's birthday, and she went to Miss Carmelita for her bouquet of prayers, but Miss Carmelita became furious and told her not to come back, that she was dishonest, a liar, a thief who stole from God, and that she was going to tell the Mother Superior. Poor Consuelo. She was a good girl who sang beautifully, and the little ones at the convent, we loved her dearly because she was very maternal toward us. She cried all day, so we decided that for one week we'd all offer her our masses, our communion prayers, our rosaries, our hours of silence, all of it to pay Consuelo's debts.

There was a little girl of twelve or thirteen who adored Consuelo. At every recess she was by her side, as if stuck to her. She was called Inés Peña. One day the scandal exploded: Inés's seatmates accused her before the Mother Superior of standing up twice during communion in order to receive the host. She'd done it to help her friend pay the thousands of communions she owed. The nuns screamed: "Sacrilege! Sacrilege!" They cut her off from everyone and shut her in a very dark room beneath the stairs. Everyone said that, many years earlier, in that very room, a woolly hand had claimed a girl who'd committed mortal sin.

Inés spent more than ten days locked in there, until the bishop arrived with Father Bacaus. With an incense burner and a large cross in his hand, the bishop and the chaplain, followed by the nuns, called Inés three times. They'd kept us in the back patio, but Sor María recounted the entire ceremony to us. The bishop called her three times, and in the name of God shouted that she must lie on the ground. The door stayed closed.

They recited many prayers, sprinkling holy water against the door. When their prayers were finished, the Mother Superior opened the door, and they ordered her to come out on her knees to the bishop. The bishop placed the cross on Inés's head and in a firm voice ordered the Devil to leave her body. When they thought the Devil had gone, they scattered holy water over her and made her kiss the Christ. Then the bishop took her by the hand and led her to the chapel, where he took her confession himself. The poor thing didn't last very long at the convent. The bishop made her write to an aunt, the only family she had, and that aunt came and took her. But you can imagine what an example she set for the rest of us.

I can't say we loved Miss Carmelita; on the contrary, we knew that a lot of what we did wrong, the nuns learned about because of her, because she had her followers, who fed her all the gossip.

Each one of us had a personal reason not to like her, but when we knew that she was sick or that she'd lost her appetite and didn't want to eat, we were seized by a terrible anguish. We all, in a chorus, prayed rosaries and rosaries so that the Virgin wouldn't let her belt close. Because if Miss Carmelita died, we knew that no one would keep track of our debts to God.

A big hug
Emma
Paris, March 28/70.

Letter Number 15

My dear Germán:

We were known as "the New Girls" for more than a year, until another new new girl arrived. That very day we recovered our names.

We'd already begun to fit in, but hearing ourselves called by the same names that Mrs. María and Betzabé once used shifted everything for us. I began to feel courage enough to pry myself away from Helena and talk to other girls. From our long months of observation, we already had an idea about the nature of our peers. We knew which ones were mean, which ones we liked or rubbed us the wrong way.

Of all the cliques, the one we liked the most was Ester's. There were six girls, a little older than Helena, but they seemed nice, less ordinary and vulgar than the others. They'd never spoken to us, but none of them had ever done us any harm. When the other girls took off my underwear, none of these girls had participated. They were very happy and spent their time inventing new games. Ester wasn't the oldest,

but she was the leader of the group; perhaps eleven years old and very pretty, blond with gray eyes, always very clean. Everything she did, she did well. She was the best at jumping rope, at playing ball; she sang beautifully and had a sweet voice; she never laughed without sticking out the tip of her tongue and had a playful face and a contagious good nature. Her father was a French sailor whom she'd never met, and her mother a girl from Santa Marta who drowned at sea when Ester was only three years old. Her father was never heard from again, and a family took her in and brought her to the convent in Bogotá. One day I got lucky: they put us both to work sewing the same piece. It was a frilly decorative cloth for a church altar, and they had the two of us pulling thread from the lace. One day I found the courage to tell her I'd like to belong to her clique, and to ask if they would accept me. That same day, at recess, she spoke with the others, and, after making me swear in the name of God that I wouldn't betray them, they took me in. I didn't know exactly what that meant, but I knelt in a corner and swore. Helena, for her part, had started making friends with a girl named Barbara, who was much older than she was.

Ester's friends were: Estela, whose two older sisters belonged to other groups. They all said they were daughters of a very rich man from Tolima and that their mother was a servant in that man's home. Estela was a little pretentious and vain, but she had good manners and was very intelligent. Rosario, for her part, was a normal girl whom the nuns humiliated constantly because her mother had a vegetable stall in the market and because, like the others, she

had no father. Teresa was the clown of the group, the one who made us laugh; she was fat and round, and we called her "Barrel." Her mother worked in a big bakery, and every week she'd send her daughter sacks full of delicious bread, which Teresa never failed to share with the girls from the group. Inés was the romantic, always daydreaming, the only one from our clique who'd gone to school and learned to read. She had a prodigious memory and could narrate the books of stories she'd read page for page. More than telling us about them, she recited them. We knew almost nothing about her. A high-class woman from Bogotá, with the last name Uribe, was her guardian and visited her two or three times a year, bringing her clothes, but she didn't know who her father or mother was. I told them all what Helena and I had agreed on: I didn't know who my father or mother was, and I remembered nothing about the past. As I told you before, we never betrayed our secret.

I don't know how long it had been since the New Girl had arrived; in any case, I was already an active member of the clique, and I'd started growing claws, as the nuns liked to say. In other words, I'd begun planning pranks with my friends. The New Girl, like all new girls, was still alone, no group had adopted her, and she was the saddest girl I'd ever seen in my life. She must've been around ten, very skinny, as pale as wax, with a large head out of proportion with her scrawny body. That wasn't all: she had very curly hair that fell to her shoulders in tight ringlets. The nuns hadn't succeeded in braiding it the way they had with the others. Every time she undid the braids, the

curls came back. Her eyes were huge, and I don't know why they reminded me of the Boy's eyes. Black, enormous, with long lashes, they gave the impression of seeing beyond; they were deeper, more profound than the eyes of the other girls. She walked as if on air, as if her feet didn't touch the ground, and all her sadness was reflected in her mouth. I don't know . . .

I can't explain it.

I'd studied her closely, because in chapel they'd placed her next to me so that Sor Teresa could teach her to behave; and though she was older than I was, we were about the same size. Hers was a mouth that asked for help, always frozen in a gesture of deep pain.

Saturday afternoons were our only free days, the only time we had to take care of our clothes, the day we washed, sewed, and ironed what was ours. Sor Teresa gave us pieces of old rags or old clothes taken from who knows where, and we would patch and alter them. Everyone wore the same smocks; when you arrived, they gave you two, a new one, only for chapel and holidays, and an old one, for daily use, which we washed on Saturdays so we could wear it again on Sundays. So in fact, Saturday was the only day we could dress in anything other than the uniform. We wore the pieces of old dresses the nuns gave us. Of course there were many girls who had family or guardians who brought them clothes, but for those of us who had no one, it was the nuns who clothed us in what was donated by the so-called benefactors of the convent.

On one of those Saturdays, Sor Teresa had tossed a sack full of rags down from the second floor, so that

each of us could take what we needed; naturally we threw ourselves at it like vultures at a cadaver and battled savagely for whatever tiny scrap we needed to patch a pair of underwear or a slip. It was a gray, terribly cold day, and in the air you could feel a storm looming. The thunder and lightning began, and then suddenly, with a crack, it was a genuine downpour. We felt thunder scratching the very roof of the convent. Educated in the way we were, taught to fear hell, death, sin, and the Devil, we were terrified of thunderstorms.

We sought shelter in the only covered courtyard we had, and with every clap of thunder we prayed aloud and begged for mercy. It was a very small courtyard, just below the embroidery workshop; here we kept the lockers where we stored our *toilette* kits, each one hanging from a nail and bearing the name of one of the girls. On the tables were large, miserable tin bowls in which we washed our faces and our feet.

I was so frightened by the thunder that I ran between the girls' legs and snuck into one of the lockers. To my great surprise, I found that the New Girl was already there, rivers of tears falling from her unblinking eyes. Instinctively I began to stroke her head, and with a piece of my skirt I wiped away her tears. At that moment a clap of lightning struck the convent's attic, and all of us felt the building shake, a red, green, blue, and yellow flame illuminating everything. The New Girl and I held each other fiercely; our faces pressed one against each other. Our tears blended, and I don't know how long we embraced, perhaps it was a long time, because the storm raged on with the same intensity. Little by little it subsided,

but the courtyards had become lakes, and the nuns told us to wait until the water had receded. I started talking with the New Girl. I asked her what her name was, and she said María. She told me she didn't have a father but had a mother and a much older sister, who was married and had two kids. She also had a little brother, and when I asked where he was, she started to cry. I stroked her head once more. I loved touching her curls. Then all of a sudden she got very serious, and in a firm voice she asked me:

"Are you my friend?"

"Yes," I said. "I'm your friend, and I love you."

"If I tell you something, do you swear not to tell anyone?"

"Yes, I swear."

"Who do you swear by?"

"I don't. The Virgin . . . Yes, by the Virgin, I swear, New Girl, that whatever . . ."

The New Girl interrupted. "No. María."

"I swear by the Virgin that whatever María tells me, I won't tell anyone."

"Kiss the cross," she said.

I made a cross with my fingers and kissed it.

"Come closer . . . Here . . . Closer . . . Like that, and put your ear close to my face. Like that. Now I'm going to tell you. I told you I had a little brother. Yes, well, I brought that little brother to the convent. He's with me."

"And where are you hiding him?"

"Wait, I'm going to tell you. When my brother was born, he was so small that my mother didn't see him, and so I stole him. Ever since, I take him with me

wherever I go. But now, since I'm in the convent, the poor thing is hungry, because what they give us isn't enough for two, and when I don't feed him, he doesn't come out to the world, and if he doesn't come out to the world, I don't hear anything from my mother or my married sister, or from my friends that I had outside of here. Are you going to help me? Yes, tell me, are you going to help me feed Tarrarrurra?"

"Who's Tarrarrurra?"

"That's my little brother's name."

"But I want to see him. Where is he?"

"Here, here. Wait."

She lifted her skirt, revealing a little red velvet pouch tied to her waist. She took it off and from inside pulled out a minuscule doll, a figurine no more than five centimeters high, made of white porcelain, its arms firmly at its sides and its legs stuck together. It was so worn it had almost no nose, no mouth. Its eyes had a small black dot in the center.

She placed Tarrarrurra very softly to her ear, and from behind her lovely hair she began to smile. Her face had been transformed completely. It was radiant, and her eyes gleamed as if they could see beyond the walls. Every now and then, she'd tilt her head and say, "Yes, yes, of course I'll tell her, but on the condition that you promise you'll go out in the world every night while we sleep and bring us lots of news. Yes, you have to tell us everything that happens in the world. What? You need to pee? But it's raining, I can't take you. They won't let me cross the courtyard. Yes, I promise I will, just as soon as I can. Now I'm going to put you away, and you sleep until I can take you to pee."

The dialogue ended. She put Tarrarrurra back in the bag with the same slow, steady gestures, then tied the bag once more to her waist, smoothing her skirt and fixing every last pleat. I was charmed and captivated; my admiration and love for the New Girl and her little brother had begun to invade my thoughts. I didn't want to lose them the way I'd lost Eduardo, the Boy, Betzabé, and Mrs. María. I'd already decided I was going to protect and save them.

"Tell me what Tarrarrurra eats."

"He eats everything," she answered calmly.

"*Everything* everything?"

"Yes, everything everything. Only he eats a lot. He asks me for food all day."

"I'm going to help you. I promise I'll give you part of my lunch and my dinner, but if that's not enough and he doesn't want to go out into the world, well, we're going to have to tell my friends so they can help us. There's six of them. You know them."

"Yes, I've seen them with you, but do you think they won't tell anyone anything?"

"I promise they won't, because we've all sworn that we'll never tell our secrets to any girl outside the group."

"What if they don't want me in the group? What if they don't want Tarrarrurra?"

"I promise they're going to adore him, you'll see. I'll talk to Ester, and if she agrees, the whole group will agree."

"But while you talk to her, you'll give me food, something for Tarrarrurra at dinner tonight?"

"Yes, I swear. Wait for me after dinner, here, here, in front of the locker."

"No," she said. "In line by the bathrooms, because Tarrarrurra can't eat in front of the others. I have to go into the bathroom to feed him."

"Okay. I'll meet you there. I'll take my sewing bag and give it to you. I'll put the food in there."

She nodded and ran off to the bathroom.

The food they gave us was pretty miserable. Dinner, like lunch, was always a clear porridge with vegetable stalks, a spoonful of rice for each girl, and a trivial portion of barely chewable meat, always boiled within the porridge. We called it *chimbos de carne*, pieces of meat never larger than an almond. There were usually two potatoes, often filled with worms, and a very green banana to round out the meal. That night I hid my meat and the banana, so I could give them to the New Girl, who was waiting for me in front of the bathrooms, just as we'd agreed. She took the bag and locked herself in. I ran to look for Ester, took her to a corner near the trash cans, and told her all about Tarrarrurra. She was as entranced as I was. We went to look for the New Girl and asked that she show us Tarrarrurra. She didn't let us touch him. She'd hold him in her hand but wouldn't give him to us; we could only touch his little head very softly with the tips of our fingers. Ester talked to the whole group, and everyone agreed we'd help with food so Tarrarrurra wouldn't starve to death and so he could go out to the world and bring us news. It was always in front of the bathrooms, where each one of us would bring a little bag in which we'd hidden part of our meal to give to the New Girl.

EMMA REYES

Carrying pouches of cloth was very common, since most of the girls didn't play at recess but took advantage of the break to do a little work for themselves. They did a lot of what we called *dechados*, samplers of different types of stitches, while others monogrammed their clothes in cross-stitch or practiced their crochet. In other words, since it was common to carry a sewing bag, no one noticed our trick. The New Girl took the bags and disappeared into the toilet. Then we waited in the courtyard, seated on the ground. We watched her coming toward us, her slow, floating gait, her face smiling and her large eyes fixed on us. She sat in the middle, and we closed in around her. It was then that she told us what Tarrarrurra had seen during his night out in the world. It was marvelous. I don't remember any of the stories exactly, but I do recall the wonderful details with which she described her house, where there was a black cat that hunted rats and ate them alive. She told us about the neighbors' cow, who, according to Tarrarrurra, had given birth to a lovely little calf that they'd baptized with the name Campana. She told us that Tarrarrurra had discovered her sister playing in bed with the policeman from the corner, and that both of them were completely naked, and that one had touched the other's privates. She told long stories about her mother's friends, and about a garden they had. Naturally the stories were often interrupted; whenever she spoke, she had Tarrarrurra in her hand, pressed against her ear, and when she paused, it was because Tarrarrurra was speaking to her. Sometimes he asked to go to the bathroom; sometimes he said not to keep talking, because he didn't want her to share

that. Sometimes she didn't tell us anything at all, because Tarrarrurra hadn't gone out into the world, because he'd had a toothache, or a stomachache. For us, Tarrarrurra was a living being who ate, who slept, whose teeth or stomach hurt, who could go out into the world and see what we couldn't. And so we were willing to live for him.

One day the New Girl let us know that Tarrarrurra didn't want to eat potatoes anymore because they upset his stomach, that it would be better if we could give him more plantains and bread and meat. We obeyed blindly. The joy of hearing the New Girl sharing what Tarrarrurra whispered in her ear was worth all such sacrifices. He never repeated the same story. He had fabulous adventures out in the world. Sometimes he entered the homes of the rich where, he told us, all the plates and teacups were made of gold or silver. He described wealthy men and women wearing splendid clothes of velvet and satin. I don't think we thought about the Devil, or sin, or hell in all that time. Tarrarrurra's stories alone were enough to fill our lives.

I remember it was a Sunday, and we'd spent that morning, like all Sunday mornings, in the great hall going over the catechism and Sacred History. They'd taught us in Sacred History that God had expelled Adam and Eve from paradise, naked, with nowhere to go, that God and all the angels held flaming swords in their hands, forcing Adam and Eve to go because they'd disobeyed, they'd eaten a fruit that belonged to God, a fruit they'd been forbidden to touch, because paradise was full of fruit, and they could eat all of it,

any fruit, except apples. They'd never seen God as furious as on that day, and from then on, man had committed sin.

We left class at noon, and I was genuinely worried for Adam and Eve, whom I imagined naked and aimless, wandering through the fields. From class we went straight to the dining room. I'd saved my meat for Tarrarrurra, but I was so hungry I couldn't save him the plantain too. I went from there straight to the bathroom. The New Girl was waiting. Ester had already handed over her sewing bag. Teresa and Rosario came behind me with theirs, and after them, Estela, and the last two, Inés and Julia. No one had seen the Mother Superior standing beside a column directly in front of the bathroom stalls. When the New Girl, holding all the bags, went to open the door to the bathroom stall, a hand reached out and took her by the arm. It was the Mother Superior. She didn't say a word in front of us, but instead took all the bags and led the New Girl very slowly by the hand across the three courtyards. We watched them disappear through the final door that led to Miss Carmelita's courtyard.

That was the last time we saw the New Girl.

Sor Honorina took her to her mother's that very day. Neither the Mother Superior nor any other nun told us anything. Every day we waited for the Mother Superior to call us, or perhaps punish us. We couldn't know if what we'd done was good or bad. The fact that they'd expelled the New Girl like Adam and Eve from paradise made us think that perhaps we'd committed a sin, though no one told us anything, and we didn't say anything, and our lives went on exactly as

before. The New Girl had taken with her some part of us we couldn't name, as if we'd suddenly become old. Yes, as if our childhood had ended with Tarrarrurra. Many months passed, and we didn't speak of Tarrarrurra anymore, because each of us held him, safeguarded him, among our childhood's most cherished memories. Our group of friends stayed solidly united, brought closer together by a kind of complicity, as well as the great solitude and sterility of our inner lives.

I think it had been about five or six months since the New Girl had been expelled, and, as usual, we gathered in the hallway before the last prayers in the chapel. The Mother Superior seemed worried, or in a bad mood. First she told us about the feast of Saint Joseph, a poor and humble carpenter, cutting wood planks, she said, nailing like any ordinary worker. Him—the man chosen to be Jesus' adoptive father. She told us to take his humility as an example, and then she paused for a long moment.

"And tomorrow's mass," she said, "will be a requiem. I ask that you pray for the soul of one of your peers who died yesterday. Most of you knew her only by sight, never even learned her name. You called her the New Girl. But a small group of you knew very well who María was. Pale and transparent María, thin and scrawny . . . When they brought her, her family never told us the girl was sick. The poor thing was crazy. She'd gotten it into her head that a doll she carried all the time was her little brother. Two days ago, her family took her on a trip to the Bogotá River. She wanted to bathe her doll, and he slipped from her hands and sank to the bottom. When her family

realized what had happened, she'd already thrown herself in, headfirst, to save her doll. Unfortunately they couldn't save her. They found her just yesterday. She had her doll clutched tightly in her hand."

Bye.
 Cheers. Hugs.
 Emma.

Letter Number 16

My dear Germán:

The night the Mother Superior announced the tragic death of Tarrarrurra and the New Girl was the same night I wet my bed in my sleep. That had never happened to me before. In that sense Mrs. María had taught us well, and when I got to the convent the nuns had given me a bedpan that was always under my bed. After lights out, the dormitories were locked, and if any one of us felt the need she had to ask the nun who slept with us for the key. But walking alone through the convent filled us with the darkest fear, so unless it was really serious, we held it until the morning bell. In my case, since I was the youngest, I had the privilege of a chamber pot for the first three years. The beds were made of wood and board, with mattresses of hay and covered with a heavy sheet that differed in color from dormitory to dormitory. In the María Auxiliadora dormitory, the sheets were blue; the ones in Don Bosco were yellow; in Santa Teresa, green. In my dormitory, the Baby Jesus dormitory,

the sheets were red. When I wet the bed, the color ran, staining everything. I didn't tell anyone, and made the bed very quickly so the nun wouldn't see the stains on the sheet, but when I went to the chapel to pray, Sor Teresa saw that my legs were all reddish. I hadn't thought of that, and in the early morning darkness neither Helena nor my friends had noticed. I felt Sor Teresa pick me up by the braids. "Go outside and wait for me there."

I did as I was told, my knees trembling with fear. When the girls had finished filing in, Sor Teresa came out, and without giving me even a moment to open my mouth, she struck me, punching and slapping me all over. Then she took me by the ear and with giant steps dragged me to the dormitory, where she had me strip the bed. The smell of urine-soaked hay was piercing. Sor Teresa yanked my braids once more and started rubbing my face against the mattress, the same way they did with the cats at the bakery when they peed outside their litter box. When we went back to the chapel the mass had begun, and all heads turned to watch me. I cried through the entire service. After breakfast, they sent me to take the mattress and the bedsheets up to the roof so they could dry. Ester and Teresa helped me. They also helped me clean my red-stained legs with soap and a scouring pad.

But the same thing happened the next night, and the next, and the one after that, and the fifth night too. I tried desperately not to fall asleep, but sleep always overcame me, and as soon as it did I'd wet the bed. The mattress kept staining everything red, and the smell of wet hay was intolerable. I felt that odor chasing me all day long, and I carried it with me, to

remind me of my torture. I regarded the coming of night with real terror. I prayed to Jesus and the Virgin to give me the grace not to wet the bed, but no saint heard my prayers, and the nuns intensified my punishment. They forced me to spend mass on my knees in the center of the chapel, with no right to sit or stand. The pews had wooden kneeling boards, which were far better than the brick floor for kneeling. By the third day I began to suffer from vertigo, and I'd fall to the ground, splayed out like a dead woman, my forehead bathed in cold sweat. I'd surely been weakened by the anguish and by my dreadful efforts each night to keep from falling asleep. The mattress didn't manage to dry out during the day, and I had to sleep atop the damp hay. Because my fainting spells had become a daily occurrence, they decided to change my punishment. Throughout recess they placed my mattress on my head, and none of the girls could talk to me or come near me. And it wasn't just that I no longer had the right to play with or speak to my friends; now the other girls, the mean ones, who were the majority, entertained themselves by insulting me and pinching their noses as they walked by. I couldn't take much more. I'd lost weight and I could no longer work in the sewing workshop because I felt dizzy and because my eyes hurt terribly from crying all day. All the punishments were useless. I kept wetting the bed every night. The Mother Superior was getting alarmed, and one day she called me to her office. She gave me candy (we hadn't seen candy since the times of Mrs. María). I don't remember what she said, but she caressed my head and patted my cheeks and gave me a medal of the Christ Child standing atop a ball,

which she said was the world itself. She placed the medal around my neck on a ribbon of black silk lace and told me to go to the infirmary, that Sor Teresa was going to give me medicine to cure me from my shameful malady. Three times a day Sor Teresa gave me a large cup filled with a blackish, slightly greasy sort of broth, lacking salt and tasting a little bitter. At nighttime Sor María would wrap me from the waist down in a wool blanket.

Many days passed without the medicine having any effect at all, and each day it tasted worse. One day I asked Sor Teresa what the broth was made from, and she answered very seriously that it was made from mice.

"Mice? Those black animals that scurry along the ground in the bakery and the kitchen?"

"Yes," she said. "From those black animals that scurry along the ground in the bakery and the kitchen."

She hadn't finished her sentence before I'd started vomiting. I threw up for three days, but I never once wet the bed again. As a prize they gave me a new mattress, with red fabric like the old one. Ever since I've had a special connection with mice.

In September we had spiritual exercises. Every year, on the same date, we suspended all our work for five days. During those five days, we weren't allowed to speak a single word all day long. Even the recess was silent and we couldn't play. They often sent a priest from outside to visit our convent during this time, usually one named Father Beltrán. Not only did he speak eloquently, but he was also so handsome you wanted to die. I don't think there was any girl, old or young, who wasn't in love with him. He was

tall and thin, with mesmerizing green eyes and a deep voice rich with subtle tones that swaddled us like a cloud. Old Father Bacaus came for mass, and the beautiful one came to teach us twice a day, at eleven and at five in the afternoon. The main topic was sin; in fact, the goal of the spiritual exercises was a comprehensive and meticulous confession of all the year's sins. We were supposed to use those five days to search for the sins hidden from us in the darkest corners of our conscience. Father Beltrán's mission was to help us find them.

Every morning and afternoon, he lectured on the commandments and analyzed us from top to bottom. The commandment he was most passionate about was the sixth, which was the one we understood the least. The little ones, most of all, demanded to know what fornication was, and with a malicious smile, he'd say:

"Those are all the sins against modesty, for example, undressing in front of your peers, or showing one another parts of your body."

And from there he started talking about passion, which he compared to a tempestuous sea. He'd been born near the sea, and described it so violently that we, who'd never seen it, were terrified of its monstrosity. Those lectures were thrilling for us. That priest was a genius. He'd imitate the noises, the birdsongs, the howl of the devils in hell, and he was so handsome that even when we didn't understand what he was saying to us, we were happy.

We spent the whole day in the chapel, coming out only to eat and walk around the courtyard for ten minutes in silence. What I didn't like, though, was the

holy hour. The Mother Superior herself read it. She had a very sweet voice and she read very well, but there were things that were so macabre that I still get frightened when I think of them. It was a detailed description of our entire body at the moment of death. *When our glassy eyes start to lose their sight . . . When our tremulous, bruised lips . . . When our cold, numb feet . . .* And in those chilling terms she described the hour of our death.

The fourth day was a sort of general rehearsal for the confession. We had the right to go to Miss Carmelita on that day so she could write down the principal sins on pieces of paper for us, so we wouldn't forget them. At confession we would pass these slips through the window to the father. This made the process go more quickly, because on the fifth day poor Father Beltrán had to confess us all in a single day. He'd finish at eight in the evening, dead of fatigue, and we'd invent all sorts of doubts and nonexistent sins, such was our desire to speak to him as long as possible. The poor thing would have to tell us that this or that was not a sin. Confession began with the older girls, and we younger girls went last.

We'd been in the convent for three or four years, and the nuns still had no idea how to solve our problem. They could never determine if we'd been baptized, so we were still unconfirmed, unable to take communion. There were only four of us who didn't take communion, the two Santos sisters and us. The Santos girls had their first communion before we did, because eventually they were able to find their proof of baptism. I couldn't bear not to confess with the

other girls, and the opportunity to speak in private, alone with Father Beltrán, seemed marvelous. Since the younger girls went last, by which point the nuns were tired of looking after us, they sent Sor Honorina, the Italian nun whom we liked so much. The old nun sat close to the confessional with her breviary and fell asleep. I went behind her and knelt, trembling, in the confessional. Suddenly from above my head, I heard a very deep voice:

"Confess your sins, my child."

I raised my eyes and realized that if I didn't stand, I wouldn't be heard because I couldn't reach the window.

"Forgive me, Father. This year I've wet the bed many times."

Through the holes in the window I saw the priest cover his mouth and then heard him clear his throat.

"Forgive me, Father. I haven't done my first communion because the sisters don't know if we belong to God or the Devil. Forgive me, Father, because I'm confessing without permission from the nuns."

He could no longer help himself, and he started to laugh. "You're the little girl with the black glasses?"

"Yes, Father."

"What's your name?"

"Emma."

"Emma what?"

"Reyes. Kings. Like the Three Kings."

"How old are you?"

"No one knows, but I say I'm over ten."

"Go. Don't worry, child. I'll speak to the Mother Superior to see how you can do your first communion. I'll take care of it. Receive the blessing."

When I stood up, there were three nuns behind me: Sor Teresa, Sor María, and Sor Honorina, who'd woken up. Sor Teresa grabbed me by the arm, but I held on to the confessional, and accidently drew back the purple curtain. Realizing what was happening, Father Beltrán stuck out his head and, his face full of fury, said:

"Please, Sisters. Don't punish that girl. She needed to speak to me, and she's done right to come to the confessional. Let the children come to me!"

The three sisters melted away, all smiles, and said nothing more to me after that.

The spiritual exercises always ended on Sunday. The only feast days we had all year were that day and the Mother Superior's birthday. They decorated the chapel with ornaments and luxurious fabrics, filled vases on the altar with flowers, illuminated all the saints, and lit twice as many candles as usual. The closing mass was led by Father Beltrán, who looked even more handsome surrounded by the ornaments. In preparation for communion, he gave us a sermon; he'd tell us that now that we'd completed the magnificent spiritual exercises, he could see above us an aureole of purity and he hoped that we'd keep our souls as pure all year round as they were on this day. Then he'd give us communion, and we'd all sing the Te Deum, full of fervor and gratitude for all the prayers God fulfills. That day was the only one all year when the nuns ate breakfast with the father in a specially prepared room, and we had permission to talk through breakfast. We were given a piece of cheese and an extra bread roll, and we even drank chocolate—very thin and watered-down, but

chocolate all the same. What a marvelous day! After five days of not talking, we shouted like crazy, invigorated, and of course the main topic was Father Beltrán, so lovely, so handsome, and everything he'd said during his lectures. There was nervous laughter from all corners of the dining room. We had all day Sunday free, for ourselves.

Letter Number 17

My dear Germán:

A couple weeks after the end of the spiritual exercises, the Mother Superior had us gather in the main courtyard at recess to present to us the new nun who'd come with the title of Treasurer. It was a new position. Until then it had been the Mother Superior herself who did the accounting and Sor Honorina who did the shopping and bought the groceries.

The first thing the Mother Superior told us was that Sor Evangelina Ponce de León belonged to one of the most famous and distinguished families in Colombia. That she had renounced her wealth and status in order to dedicate herself to the humble religious life. That we should be grateful to the Virgin for having sent us a woman of such distinction and piety who would accept the sad responsibility of looking after the economic interests of our modest home.

Sor Evangelina Ponce de León was of medium height, a little fat, pale like church wax, and had downward-sloping features. Her brown, pointy eyes

drooped, her nose folded over itself, like a tilting hook, and her fine, pursed lips curved downward, toward the floor. Only her ample bust and her large backside had lift, as if pointing the way forward, and creating distance between her and others. All her pretension was reflected in those two parts of her body. Her sharp teeth were very white, and when she spoke it looked as if she might spit them out. Her hands were bony hooks with very long fingers. She spoke quite slowly, her head always held high, always looking down on us. When she had to touch us, during an observation or to make her way between rows of girls, or in the workshops, she did so only with the tip of her index finger, like someone touching something unclean or contagious. When the nuns referred to us in public or in private, they called us "little ladies." Sor Evangelina called us "girls," and when she was upset, "scamps."

She, too, spoke that day the Mother Superior introduced her. She promised she would make various changes to the food and some changes to the distribution of work so we could make more money.

"Don't forget you're all here because of charity, and that you have to work to pay for what you eat. You can't think that the world gifts us the food we give you, no. We have to pay for it with money, and that money we have to earn through our labor."

She promised us that next year they might make us new uniforms for the feast days.

"We've also been thinking with the Mother Superior that we should pay more attention to your education. You should all learn to read and write, even if it's just your own names. We'll also teach you a bit of

arithmetic; in life you have to know how to count. Geography. How many of you girls know what geography is? Surely none of you. Someday you're going to have to go back out into the world, and out there geography is very important."

The lessons began the next month. She'd come to the workshops for half an hour each day and, without interrupting our work, teach us math from memory. First she taught us to count to twenty, then she taught us that one plus one was two, and two plus one was three, and three plus one was four, and on and on until we got to twenty. She called that adding. Then she taught us to multiply. If we multiply two by two, we get four. It seemed to me that was just like adding—two plus two is four is the same as saying two times two is four. Monday was arithmetic. On Tuesdays we repeated the names of the letters from A to Z. She taught us there were only two letters that were doubles: Ll and Ñ. Wednesdays were geography, which she adored. She taught us what a river was, and the difference between a mountain and a hill. She said that each city, like each person, had a name, and she taught us the names of the most important cities in Colombia.

On Thursdays she'd teach us national history. She told us about a man named Simón Bolívar, who was the father of our country. She taught us to sing a verse about Bolívar that said:

"One hundred years ago, that immensely sad hero died by the sea. Bolívar is our father, our fatherland, our nation."

She taught us what Atanasio Girardot proclaimed when he climbed a hill through a hail of enemy

bullets: "Allow me, Father, to plant this flag atop this mount, and if it's your will that I die today, I'll die happy." And boom! A bullet pierced his heart, and he collapsed dead, wrapped in the national flag.

The national flag was three pieces of cloth sewn together, one yellow, another blue, another red. The yellow signified the gold and riches of our land, the blue the water of the oceans that surrounded our country, and the red the blood of our heroes spilled on the battlefields.

On Fridays class was held in the large courtyard, during recess. We gathered in rows of ten. It was a gymnastics class, to make us grow and not stay so scrawny. We'd begin by lifting our arms toward the sky, then cross them, then stretch them in front of us, then fold them against our chests, then once more above, quickly to the back, to the front again. We'd finish with our arms hanging down, hands wide open. These exercises were accompanied by verses, which we all shouted in chorus:

> Courage, young ladies!
> Down with laziness!
> If we work optimistically
> We'll soon be
> Strong enough
> To be young ladies
> Worthy of honor!

Unfortunately that's as far as our cultural education went. Sor Evangelina got sick, and neither she nor any of the other nuns ever gave us classes again. The first day that she taught the gymnastics class, she

emerged from the cloister with Sor Honorina behind her, carrying a sort of wooden stool, cushioned and covered in red velvet. Sor Evangelina pointed to the spot where she wanted it, then climbed up, clutching Sor Honorina with the tips of her fingers and leaning her weight on her. Not only could she see all the way to the last one of us, but she could also talk down to us from above. As always, the little girls were in the front row. I was the first one, and next to me were the Santos sisters. Next to them, the two Vaca sisters, Teresa and Asunción. After the Vacas was Helena. Sor Evangelina watched her constantly, for the duration of the class. When it was over, she raised her hand slowly and with her index finger pointed to Helena and ordered her to come forward. I watched my sister step out of the row of girls, fear spread across her face.

"Come here, girl."

From above, Sor Evangelina looked at her head and asked if she had lice. Helena said no, it was her sister who had them (and that was true: lice never left me alone). She rested her hand on Helena's and climbed down from the stool, and with her finger signaled to Helena to carry it and follow behind her. From that day forward, Helena became Sor Evangelina's slave. She had to follow her all day with the stool, and when they were in her quarters, Helena did all her chores, even shining her shoes, taking away her bucket of dirty water, carrying her clean water, and going to the kitchen a thousand times to bring her teas and broths and braziers with lit coal to warm her feet.

Beneath the chapel, in the Flores courtyard where Miss Carmelita stayed, there were three large rooms

used for storing cloth and decorations. Sor Evange-
lina had them emptied, and that's where she made her
home. She didn't follow the rules like the other nuns.
She had all the privileges, almost more than the
Mother Superior, because the Mother Superior ate in
the cloister with the other nuns. Only Sor Honorina
accompanied us in the dining room. But Sor Evange-
lina mostly ate alone in her apartment, and it was
Helena who brought her her meals. The first few
months, when we were still receiving our lessons,
Helena slept in the Baby Jesus dormitory, same as me;
but when Sor Evangelina fell ill, she had Helena move
her mattress and sleep on the floor next to her bed, so
she could call her at any time and Helena could pass
her medicine, a glass of water, or whatever she
needed. Her friends and family would visit her on
Sunday afternoons, and that was the only day she
didn't keep Helena by her side. Instead, after lunch,
she sent her to be with the rest of us.

Helena told me and my friends that Sor Evange-
lina was good to her, that she gave her half of her
very good food, that she'd already made her two new
sleeping gowns, and that she gave her lessons every
day. Helena already knew how to count to a thou-
sand and knew her multiplication tables up to ten.
Sor Evangelina had taught her to read perfectly and
had her read the life of the saints or the passion of
Christ. One day she told us they were reading the
story of a very young and very beautiful saint who'd
had both her eyes taken out with spoons, her breasts
cut off, and all of it placed on a large silver platter
that had been offered to a rich and powerful man; but
then the angels came down from heaven and took the

saint to paradise. The rich man, who was very bad, had gone blind as God's punishment. Another time she told us that Sor Evangelina had given her a book called *Colombian Reader*, which had many stories, but when Helena came to see us, she wasn't allowed to bring anything.

In May, on the Virgin Mary's feast day, the Santos sisters had their first communion. I don't know who brought them those beautiful, long white dresses. On their heads they wore translucent veils held by crowns of blue and pink flowers. Because they were blond with light eyes, they looked lovely. They were allowed to wear their dresses all day, and they went from room to room so we could admire them. I watched them and touched them with terrible jealousy. I imagined God's angels in heaven were just like them.

One day Helena came for me in the sewing workshop because the Mother Superior wanted to talk to us. We went to her desk, and she gave us the key to the dormitory so we could put on the smocks we wore to mass, wash our feet, face, and hands, and brush our hair. Helena was braiding my hair when Sor Evangelina appeared. She told me to take off those horrible black eyeglasses and said we were going to see the bishop and that we should kneel and kiss his hand when we reached him.

The bishop was waiting for us with the Mother Superior, in the same room we'd entered the day the nuns first brought us to the convent. When I kneeled, I saw that the bishop's robes and socks were red, and I started to cry. No one understood why I was crying. The bishop tried to touch me, and I backed up against the wall. The Mother Superior told him how some

Indians had abandoned us in a train station, and that other nuns and a priest had taken us in and then brought us here. Nothing was known about our family, and worse, it wasn't known if we'd been baptized. They kept talking for a while longer, and then the other nuns arrived, all very agitated. Seeing me in tears, Sor Carmelita approached and asked me why I was crying.

"Because you're going to give us to the Devil."

"Which Devil?"

"Him."

And with my finger I pointed to the bishop. They all fell silent. The bishop asked me very sweetly why I thought he was the Devil.

"Because I know him by his red dress."

They all started laughing, except Helena, who slapped me across my mouth. She knew what the bishop wanted to say.

They took us to a chapel, and the bishop gave us confirmation, and then he gave each of us a silver medal with the image of the Virgin. He gave Sor Evangelina some money and told her that they should buy us whatever we needed. Sor Evangelina bought white cloth to make us underwear, and even made Helena a bodice, because her breasts were starting to grow and had to be flattened so they wouldn't look immoral.

Sor Evangelina was tasked with preparing us for our first communion. Every day, after snack, Helena came for me, and we went to Sor Evangelina's apartment. She sat in a large chair of dark green satin, and Helena placed the red velvet stool under her feet. We sat on the floor, Helena next to her, me a little farther.

It was around then I realized that Sor Evangelina loved Helena very much. She made her work as her servant, but she loved her. She petted her head constantly and found everything that Helena said or did to be marvelous.

I was bored to death sitting through the catechism lessons and the explanations of what the sacraments were and the commandments and the sins and that the communion wafer was the body and the blood of Christ. Most of the time I didn't understand a thing she was explaining to us. Helena could already read and study the catechism; I had to learn everything from memory, and because I got so bored and distracted, nothing stuck.

Helena had a prodigious memory and easily learned things. Sor Evangelina said she was the smartest and prettiest girl in the whole convent. Helena's superiority had given me a real complex. I hated everything that had to do with learning. I liked only to make up my own stories, to imagine things; instead of catechism and arithmetic, I would rather they let me play the piano or the harmonium, go to the yard and climb trees. I preferred the stories of Tarrarrurra to the stories of Sacred History. I liked embroideries because I could make up new stitches and new ways to do them. That's why I favored Sor Carmelita, who said I was the only one who could replace her later. I don't know if she meant it seriously, but destiny wanted it to occur, because the poor thing went blind.

But about the first communion: Sor Evangelina couldn't stand my stupidity, and I felt she was starting to really hate me. One day she said:

"I can't tolerate you anymore. Don't come back. I hate people who are ugly and stupid, and you're both."

It was Sor María Ramírez who took it upon herself to prepare me for the first communion. Helena's preparations with Sor Evangelina continued.

If you were to ask me who was the first love of my life, I would have to confess it was Sor María. It was a very strange love, as if she were my mother, my father, my brother, my siblings, and my boyfriend. For me, she represented all kinds of love and every shade of tenderness combined. She was tall, very thin, with agile and elegant movements, light brown skin, and penetrating black eyes that were also a little sad. Her facial features were perfectly balanced, but they were neither feminine nor masculine. I'd say they had no gender, but a beauty and equilibrium beyond gender. Sometimes she was a bit hard and masculine, and other times she possessed an extraordinary warmth and sweetness. She couldn't have been very intelligent or educated. The fact that she was in charge of the ironing workshop said a lot about her standing. She told me her family was very poor, that she was the thirteenth of eighteen brothers and sisters. She'd been born in a tiny town near Cali. Because I was in the embroidery workshop, the most privileged one, I almost never saw her. She slept in our dormitory, but outside of morning prayers, I had very little to do with her.

I began to love her only when she was preparing me for communion. In the afternoons I'd go down to the ironing workshop, and we'd stroll through the courtyards and out to the garden. She'd hold my hand, or I'd hang on her waist. It wasn't that I learned

more with her than with Sor Evangelina, no, but it felt easier and clearer with her because she spoke more simply and also because I felt she loved me.

The preparation lasted for two months. Every day she brought me something hidden in her pockets, either a piece of candy or fruit or an image of a saint. I stole flowers, the smallest ones, from the yard, and I'd press them into her hands and ask her to keep them in her pocket at all times, so she could remember me when I wasn't with her. When we passed by the doors or the places where she was sure no one could see us, she'd hold me tight and cover my face in kisses. I'd kiss her eyes and the tips of each of her fingers. When I saw her outside of our lessons, crossing the courtyard or a workshop, or simply walking into the chapel or standing for communion, my heart would begin to race and I would lose my breath. When we weren't together, I would constantly talk to her in my head all the time or make up stories to tell her. She was the only one in my entire childhood who told me I was smart; naturally I didn't believe her. For me, the only smart one was Helena.

The Mother Superior decided that the best time for our first communion was midnight mass on Christmas, the same hour Jesus was born. I told Sor María she had to help us both get a white dress like the Santos girls, because I didn't want to receive my first communion without one. She became very sad and told me she couldn't do anything, that the only ones who could help were the Mother Superior and Sor Evangelina. That day I realized very clearly that the convent—like the world, as I would later understand—divided people into social classes, and only the privileged classes had power. Sor María never could have had the life

that Sor Evangelina led. She was as ignorant as we were of what went on among Sor Evangelina, Miss Carmelita, and the Mother Superior. Like Sor Honorina, Sor Inés, and Sor Teresa, she was simply a slave to the others, and that became clearer and more fixed with each passing day. The three women at the top were the aristocracy, the rest of us the rabble.

I hadn't seen Helena in many days, but since it was time to make the bouquets for Baby Jesus and to write the letters saying what we wanted for Christmas, I decided to go to Miss Carmelita so she could write me a quick letter to Jesus asking him for dresses. She wrote it without comment. I fled using the stairs reserved for the nuns—forbidden for us—and I went to the chapel and placed the letter next to the altar. When I turned around, I saw the Mother Superior at her prayer bench, kneeling and praying. She saw me and didn't say anything. I ran out.

The days passed, Christmas approached, and Baby Jesus didn't send our dresses. Father Beltrán came three days before Christmas to hear our confessions. I told him I'd written to the Christ Child asking for a white dress and that there were only three days left and the dresses hadn't come, and I didn't want to receive my first communion without a dress. He was furious. That was a sin of vanity, he said, and I should repent and not think of the white dress again. The only white and pure thing I needed was my soul.

On Christmas Day, Father Beltrán returned to receive our confessions and prepare us for communion. I was sad, in a terrible mood, and I don't think I heard what he said to us. At six o'clock Sor Teresa came for me. We went to the laundry, where there

was a giant pool fifty feet long and six and a half feet wide. Surrounding it were the washing tubs, though no one was washing at that hour. Sor Evangelina arrived with Helena. They made us take off our clothes and dressed us in long gray frocks. Sor Evangelina washed Helena's hair, and Sor Teresa washed mine. They made us scrub our feet, our faces, and our arms and legs with a scouring pad, then they tossed buckets of cold water on us. I thought I was going to freeze to death. I couldn't breathe. They dried our hair and took us to the dormitory and put us to bed without dinner. They said that since we were going to receive communion at midnight, we couldn't eat anything until after the midnight mass, and that they'd come to wake us at eleven. They locked the dormitory, and Helena told me I was a dumb kid, that poor girls don't get white dresses for their first communion.

"And what about the Santos girls? Are the Santos rich?"

"No, but they're protected by the rich."

I turned away and went to sleep.

Sor Teresa came by at eleven to wake us up. I could hear the shouts of the other girls waiting for the mass. I was dead tired. We put on our smocks and left the dormitory. Sor Evangelina was waiting for us in the hall. "Come with me." She took Helena by the hand, and I followed behind. When we got to her apartment, I saw two beautiful white dresses on her bed, much prettier and fancier than the ones the Santos girls had worn. My eyes filled with tears of joy.

"They belong to my nieces, but they've lent them to you. It's charity, so please be careful not to damage them or get them dirty."

Sor Teresa came running, and the two of them started to dress us. Sor Teresa talked the whole time about the beauty of the dresses. The crowns had not only flowers, but also lustrous pearls. When they put on my shoes, I was dying of laughter. They were the first shoes I'd worn in my life, and they were huge. Helena's, on the other hand, were too tight. The poor thing, she walked with a limp, while I dragged my feet so my shoes wouldn't come off. When they were finished dressing us, the bell for mass rang, and they had us go up to the chapel using the staircase for the nuns and enter through the door where Miss Carmelita heard mass. When Miss Carmelita saw us, she called us over to her and told us the dresses were beautiful. In the middle of the chapel, next to the altar, two prayer benches had been set out for us. When we entered the chapel, we could hear all the girls say, "Ah!!!" but when I genuflected, I lost a shoe, and they all started laughing—and I did too.

Mass began exactly at midnight. Father Beltrán lifted the veil that covered the Christ Child, who was resting in his red satin cradle amid clouds of cotton. The chapel was illuminated and filled with flowers. The Mother Superior stood and came over to us, motioning for us to kneel in the center of the communion table. I was very moved, and in that moment I think I truly loved the Jesus I was about to receive in the form of the host. During mass we sang the Christmas carols, and the Mother Superior played the harmonium beautifully.

When mass ended, we got up to leave through the door with all our peers, but were stopped by Sor Evangelina's hand. She took us down the private stair-

case to her apartment, where she had us take off the white dresses. We put on our old smocks and took our feet out of the shoes, and she told us to go with the others to the dining hall to eat something. All I ate were my tears.

Happy Easter.
Emma.

Letter Number 18

It was six months until the feast of Saint Peter, and the Mother Superior, as she did every year, gathered the nuns in her quarters to decide what sort of gift they were going to send to the Pope in Rome on the day of his birthday. They all agreed we should make him an embroidered robe, a floor-length alb worn at mass beneath the chasuble. The cloth they chose was a fine satin as white as a cloud.

Sor Carmelita spent more than a month doing the drawing. The central motifs were wheat and grapevines, and in the middle, in the front, was a great chalice from which rose a communion wafer with lightning, and on the lightning was a dove with its wings spread, representing the Holy Spirit. The bottom was knitted with pointelle and lace and finished off with an embroidered edge. The sleeves, too, were embroidered, all the way to the elbows; the neck and shoulders were rich in extraordinary detail. I don't think the Mother Superior was exaggerating when

she told us it would be the most beautiful robe in the world.

This was a period of intense work. The Turk, the convent's best customer, had sent three linen tablecloths, enough for a table of forty, to be embroidered. Each napkin was a square yard. Each tablecloth was to be embroidered with forty baskets, one full of flowers, another full of fruit, and the third full of birds and butterflies fluttering above bouquets of violets. The drawing went around the edge of the tablecloth in the form of a garland tied by ribbons. In the center of each tablecloth, also amid flowers, was an immense monogram: M.G.R.

The embroidery workshop was cluttered with frames, placed one beside the other. When one of us had to go to the bathroom or to wash our hands, we had to leave on all fours, crawling between the legs of the other girls. All the girls who knew how to embroider, whether they were good at it or not, were busy with the Turk's tablecloths or her napkins. They'd lengthened our workday by one hour, which they took from our recess. There was an older embroiderer in charge of each frame and responsible for the material, and she instructed the rest of us. She had to monitor the cleanliness of our hands, so we wouldn't dirty the cloth or the thread with our sweat. There were some girls whose hands were so damp that the needle screeched each time it went in or out of the cloth; when that happened, the wall behind the sink was useful. We'd rub our wet hands against its chalky surface, to great effect.

As we worked, the hardest thing to learn was not to put our fingers in our nose or ears or scratch our head

or touch our feet or put our hands in our dirty pockets. Such discipline was hardest for the beginners. Elvira Cubillos, for example, was a good embroiderer who worked with the speed of a sewing machine, but she always drooled over her work. We had to tie a towel around her mouth and neck, which made it impossible for her to speak. At the end of the day, the towel was wet enough to wring out. For the girls with runny noses the problem was worse, because they constantly had to rub their noses against their upper sleeves.

The Mother Superior and Sor Carmelita decided I would be the one to make the robe for the Pope. The only quality the nuns always recognized in me was that I was the best embroiderer; perhaps because they'd trained me so young, and I knew the secrets and tricks of each kind of cloth, each kind of stitching, the uses of each thread depending on its consistency, but also because I was the only girl with a natural talent for drawing. When it came time to embroider I didn't distort the image; on the contrary I perfected it. This assurance meant they didn't have to watch over me, and all my work turned out almost perfectly.

The Turk paid very well and gave the convent a lot of work, but the Pope's robe was more important than anything else, so it had to be done by the best hands. It also represented a kind of prize or honor. To work for the Pope was to have heaven nearly assured, and the character of those who were chosen to work for him each year couldn't be the same as those who worked for the Turk, who, according to the nuns, was an atheist. We prayed for her before work each day, that God would enlighten her and grant her the virtue of Christian faith.

I knew what awaited me with this job. Any minor mistake and they'd invoke the Pope. I wasn't worthy of working for him, I was a sinner, I couldn't so much as touch anything that was going to grace the Pope's body. The Pope is the incarnation of Christ on Earth. Everything of his is as sacred as the communion wafer . . . We knew this speech and others like it by memory, which didn't keep them from repeating it to us again every year.

Sor Carmelita had drawn the robe's design on the fabric. With her help we built an enormous frame, which we installed at the back of the workshop, where there was less traffic from the other girls. The point wasn't just to avoid accidents but to signal that this wasn't like the rest of the work. Only the nuns and the girls working on the robe could go near this frame. Sor Carmelita had traced the drawing on the lower part of the robe, the most important part, and I sketched the design on the sleeves, the shoulders, and the neck. We covered everything with wax paper and rolled it over the sticks until it was just a yard wide, then stretched the frame tight. We covered everything with two sheets, leaving exposed a section just eight inches wide, where the first part of the drawing was. I prepared the thread by thickness, the needles, the scissors, the bodkins, and the paper, which we used to give the embroidery a certain shine. When it was all ready, Sor Carmelita called the Mother Superior, who came over with a silver bucket of holy water from the chapel. She blessed the project and, while we prayed ten Our Fathers for the life and health of the Pope, sprinkled holy water around

the frame. Then she had me kneel and gave me her blessing, and with that ritual the work was allowed to begin.

For two months I was alone in my great frame like a queen. This period coincided with a mystical crisis related to my love for Sor María. I'd never loved Jesus more; I loved him as a little newborn, I loved him as he helped Saint Joseph in the carpentry shop, I loved him when he spoke to his disciples, I loved him on the cross, in resurrection, and in heaven. When I approached the altar to receive communion, my entire body trembled with love. During mass I'd stare at the eyes of the Sacred Heart and many times had the impression his lips were moving or that he was smiling at me. One day the priest came to give us confession, and I knelt by the altar, scouring the furthest recesses of my mind for my sins, fearing I might forget one. My gaze fixed on the eyes of the Sacred Heart, and I begged that he forgive me and help me to be better so I could be closer to him. Tears rolled down my cheeks. I felt like such a sinner. Again I'd told lies; again I'd felt hatred toward Sor Teresa; again I'd fought at recess when they tried to take away my ball; again I'd stuck out my tongue at Sor Inés because she wouldn't let me climb trees. I wanted so badly to be good that I thought if I became a nun, perhaps it would be easier, and maybe I could become a saint like Saint Teresa. I made the decision in an instant. Yes, I would become a nun. I went to the confessional, told the priest my sins, and when he was done giving me my penitence, I told him I'd decided to become a nun and asked whether he would help

me, because you had to have a dowry to be a nun, and I had no money.

Inside the confessional, Father Beltrán flinched as if he'd been bitten by a snake. He coughed, rubbed his nose from top to bottom, scratched an ear with his little finger, and pressed his face very close to the confessional gate. He said, "My daughter, I think you need to get that idea out of your head. I order you to. Don't think about it anymore."

"But, Father, I'm certain that the only thing I want is to become a nun. Is it because I don't have money?"

"No, daughter, it isn't about the money. It's because to be a nun, you have to have a mother and a father and have been born into a Christian family."

"Father, a girl told me that I didn't come from the ground like flowers do, that I shouldn't say I don't have a father or a mother, because without them no one can be born."

He picked his nose with his index finger.

"Your friend is right. We all have mothers and fathers, but if we don't know who they are, it's the same as being born like a flower, from the ground. And when one is born like that, you can't enter the religious life. Pray a lot, my daughter, but don't think about that anymore. You can still serve God, even if you aren't a nun."

"But I want to be a nun."

"My daughter, one doesn't do what one wants, but what God wants."

"So he's the one who wanted me to be born in sin? And he wanted me not to be a nun?"

He pretended not to hear me and began to give me the blessing.

I spoke with Sor María that same night, at recess. She told me the priest was right, and that she too would pray for me. But I didn't want to believe either of them. While I worked I thought, if I knew how to write, I'd be able to write a letter to the Pope, and hide it in one of the sleeves of the robe, so he'd find it when he put it on. In my head, I composed letters all day long. In them I told him my whole life story, told him about the Boy, about Eduardo, Mrs. María, my sister, told him also that the nuns were mean to us, that they hit us and made us go hungry. I told him that Sor María was the only one who was an angel. Other times I imagined that the Pope had received my letter and answered it, and I started imagining various responses. Other times I thought the Pope would come to the convent, that he would ask the Mother Superior to speak to me, and I'd imagine the surprised faces of all the nuns. But that was only a dream; I knew very well that, like we were, the Pope was locked in a convent and couldn't go out into the world. That's how the days and months passed, and my head got tired of thinking, and just like Father Beltrán had ordered, little by little I forgot my wish to be a nun, and I also began to forget my passion for Jesus.

One day the Mother Superior came to look over our work and realized that I wasn't going to be able to finish the robe all by myself. The cloth was too fine, the embroidery too detailed. After talking it over for a long time with Sor Carmelita, she ordered five of the girls who were working for the Turk to switch and work with me on the robe, and she ordered that we work nights too. That was great news for

us—working nights meant a thousand and one privileges. First, we didn't have to go to mass except on Sundays. We ate alone in a small room next to the embroidery workshop, and they gave us more food, meat every day, plus two glasses of milk a day. But what made us happiest was the hot chocolate and bread we got at midnight before going to sleep. Chocolate was something we were given only once a year, on the Mother Superior's birthday, or in an exceptional case when you had a deadline to meet and were working all night.

Even better: they put Sor María in charge of taking care of us at night. I think those were the happiest days at the convent. I was so happy I became a clown. I don't remember what I said or did, but I do remember that my friends and Sor María laughed until they cried. At night they couldn't make us work as we did during the day, without talking. Up at five thirty in the morning, working eighteen hours a day—if we didn't talk we would've dropped like flies, asleep atop the frame. But one night, unfortunately, we made too much noise. Ester had climbed up on a chair and was imitating all the nuns and Father Bacaus giving mass; the chair broke and crashed to the ground, dragging with it all the cords for the lamps that illuminated the frame. Naturally, everyone saw the mess the next morning. All the lamps were shattered. The Mother Superior called us in to her apartment one by one, and two of the girls decided to place the blame on me. It was the Santos sisters, who hated me because one day I'd hit the two of them after they stole the banana and the bread that Ester had given me for a stomachache. I'd managed to grab them both by the throat,

press them against the wall, and make them throw up my bread and my banana. That hadn't been easy because they were both bigger than I was, but I'd caught them by surprise when they were sitting on the ground. The Mother Superior punished me by having me work only during the day; I had to go back to the dormitory at the same time as the other girls. The Santa Teresa dormitory was overseen by Sor Trinidad. While we undressed, we prayed aloud, asking God to have mercy on us and not take our lives while we slept, and if he did, that he might forgive our sins and not close off the doors to heaven.

Meanwhile, Sor Trinidad paced back and forth staring at the floor to avoid looking at us, because if by some misfortune our shirts were to slide from our shoulders, she might risk sinning by seeing some part of our bodies. When we were all in bed, she would lock the doors and go into her tiny room to sleep, taking care to place the keys under her pillow so we couldn't steal them from her in the middle of the night. I knew all that, and naturally getting those keys was inconceivable. My bed was in front of a glass door, secured with twenty padlocks. The door led to the hallway where the Mother Superior bade us good night, and in that hallway was a great grandfather clock that sounded like the heart of a cow after it had run. That door was never opened, but the glass panes were held by tiny brads that looked like safety pins. I waited a long time, until not one of the girls was shifting beneath her blanket. Without peeking out from under the covers or taking off my nightshirt, I put on my smock and underwear; I let myself slip out of the covers and dragged myself beneath the bed

to the door with the glass-paned windows. I was barely breathing as I used my scissors to remove each of the brads until one pane of glass came free. The opening wasn't very big, but it was big enough for me to get through, bending and contorting like a worm. My heart beat almost as furiously as the ticktock of the grandfather clock. I crossed the two courtyards as quickly as I could and appeared like a vision at the door of the sewing workshop. Sor María, who as usual was mending the other nuns' socks, turned as white as the Pope's robe. The girls were dying of laughter, and even the Santos sisters seemed amused by my audacity.

Sor María wanted to scold me, but her love for me was too strong. She did make me promise never to do that again. I saw sadness in her eyes. I knew my punishment was weighing on her too. I would've liked to throw myself in her arms and kiss her face, her eyes, her mouth, tell her I was suffering without her and that I loved her more than if she were my mother and my sister combined. At that moment I loved her madly. I knelt down beside her and kissed her hands. She gently pricked the tip of my nose with a needle she was holding. I asked her to bow her head, and I whispered in her ear that it was because I loved her that I was going back to the dormitory.

"No, no," she said quickly. "I'm going down to the cloister to make the chocolate. Come with me, and then go to sleep. I'll make some for you too."

As we went down the stairs, Sor María threw her arm over my shoulders, and I grabbed her waist. In that moment I realized how big she was. I thought of a dirty old yellow photo that Inés Rozo had showed

me. She'd been born in a circus, and in the picture she held the foot of an elephant. The elephant had its eyes pierced by a needle. She told me she herself had stuck the needle in one day, furious because her mother loved the elephant more than she loved her. If her mother had really loved her more, it would be the elephant in the convent, not her. Having crossed the courtyards and the laundry in silence, Sor María and I arrived at the door of the cloister. She nestled against me, smothering me in an embrace and pressing me against her chest. Then she kissed my face all over, with such speed she must've been in a hurry. I managed only to give her a kiss on the eye.

"Wait for me here. The cups and the bread are ready. I just have to heat up the chocolate."

None of the girls, neither big nor small, ever had the right to enter the nuns' private cloister. Since we didn't know what it was like inside, we'd made up all sorts of stories about it. We imagined it the way we imagined paradise. Everything that represented happiness for us was inside: Bread, bananas, sugarcane all came from the cloister. Christmas gifts came from the cloister. The clothes we were given came from the cloister, and the nuns we loved too—because each of us had a preference for one of the nuns, just as each of them had a preference for one of us. The night sky was as dark as a new vestment, with not a single star. An icy wind lifted my nightshirt, which I pressed down with both hands to keep it from billowing up. The expansive brick courtyard was damp, and the soles of my feet were freezing. Sor María was taking too long; perhaps the coal had gone out and she'd had to light it again. I felt the clock strike the hour,

perhaps eleven or twelve. A blast of wind, stronger than the others, made me turn my head.

It was at that moment that I saw it, at the end of the courtyard, against the high wall that separated us from the world. At first it was still, then it began to move slowly toward me with its arms stretched out in front. I didn't doubt it for a moment; I knew it was him, just like the Mother Superior had described him a million times in her talks. Tall, very tall, with enormous eyes that spat fire and hair many shades of green. His horns were larger than I expected, his large white teeth protruded from his mouth, his hands were very big and nails very long, and flames shot out from the tips of his nails. He moved toward me without touching the ground, cloaked in red, violet, and green fire, and clouds of white and blue smoke hung above his head. I stood straight, petrified; only my knees moved, knocking against each other. I wanted to scream, but I had no voice. My heart didn't just beat, it raced like a galloping horse, and a cold sweat ran down my arms and behind my ears. My stomach turned to stone. He advanced without a sound; I felt a shiver run from my scalp down my back. It took him what felt like an eternity to cross the courtyard, but I knew he was coming to take me away. The rest passed in an instant. He was already so close that I could see the long hair on his arms. I don't know how I managed my first cry; I also don't know how I managed to recover enough to move. I didn't run, no . . . I flew, without touching the ground; I don't know how I crossed the courtyards, nor how I climbed the stairs, nor how I snuck through the opening where I'd removed the window.

Dolores Vaca slept in the bed to the right of mine. Everyone thought of her as a saint, and I hated her. But when I came back to life, I wasn't in my bed but in hers, my arms wrapped around her neck, shouting: "If I'm with Vaca, the Devil can't get me! If I'm with Vaca, the Devil can't get me!"

She struggled desperately to free herself from me. My cries weren't cries so much as the wild shrieks of a wounded animal. There wasn't a single girl or nun, including the woman who sat by the door at the other end of the convent, who didn't wake up from my shouting. Confusion reigned. The girls ran toward the dormitory doors, climbing over the beds, stepping and trampling on one another. The nuns came from their chambers in nightshirts, and no one could find the keys to unlock the dormitory doors. Some shouted, some wept, and all wanted to escape, though none of them knew what had happened. The Mother Superior fainted, and Miss Carmelita fell from her bed and no one could rouse her until the next morning. When they managed to claw me from Vaca, I saw Sor María by the window, covering her face with both her hands. She was the one who'd run behind me, not the Devil. The convent didn't recover until the next morning, and the great catastrophe wasn't discovered until after breakfast.

The Pope's robe was now nothing more than three gaping holes. The girls, in their haste to flee, had clambered over the frame. Sor Carmelita wept, pressing the edges of the holes between the tips of her fingers, as if hoping for a miracle that would make them disappear. At nine in the morning, the convent's bell rang once, which meant the Mother Superior was

summoning all the nuns. The meeting didn't last long; ten minutes later we saw the Mother Superior coming, all the nuns along with her—except Sor María. The Mother Superior's face was hard and severe. We all stood up, as we did whenever she came to the workshops. I was next to the frame on which we'd been making the robe when she called my name.

"Come here," she said.

I walked across the room calmly. I couldn't have done it any other way, because my entire body was coiled tight like a ball of thread, and in fact, nothing mattered to me anymore, nothing. I knew she hadn't come to congratulate me. When she told me my punishment, I was not at all surprised. A month without speaking; no one had the right to talk to me, neither the girls nor the nuns. A month working in the kitchen washing the pots and floors and carrying the water. A month sleeping alone in the room where the old furniture was kept, next to the one where the old cook slept. A month hearing mass on my knees, alone in the middle of the chapel, with no right to sit. My name was erased from the list of the daughters of Mary, and they took away my uniform, giving me instead a long thick shirt, of a fabric the color of sadness, with a rope to tie around my waist. In the kitchen I couldn't talk either, except to say what was absolutely necessary to do the work. Since no one—not the girls or the nuns— doubted that the Devil had come for me, it wasn't hard for them not to speak to me since, after all, I represented sin and hell.

A month later, when I emerged from the kitchen, Sor María wasn't in the convent anymore. No one

ever found out for sure where she'd been sent. Sor Trinidad told one of the girls that she thought they'd sent her to Agua de Dios to care for the lepers.

That year, because of the Devil, the Pope didn't receive our gift.

Emma.
 Paris, 1972.

Letter Number 19

To Germán Arciniegas:

One day, at recess, the nun who took care of the garden told us she'd seen a nest of birds up in the Midget. That was the name we'd given to the shortest, stoutest tree in the garden. She reached up and showed us the nest she'd seen from her ladder. There were four tiny eggs. I'd never seen eggs like those, and when the nun left I told my friends I was going to climb the tree. I climbed up the Midget like a monkey. When I tried to touch the eggs with one hand, my other hand clutched a branch so hard that I broke it, my body and face hitting the ground, and my stomach landing hardest. There was a little grass and some flowers around the Midget, but not enough to cushion my fall.

The pain in my stomach lasted all day. The next morning I woke hurting even more, and when I got out of bed I was terrified to find that my sheets and legs were covered in blood. I ran to the nurse and said through tears, "I broke myself. I fell from the Midget and broke myself, and I'm going to die."

She had me climb onto an old bed, where she examined my whole body, even my chest. I insisted that it was my stomach that had burst. When she was done examining me, she told me with a laugh that what was happening was nothing really, that it was normal for all women. She asked me to come back at five o'clock because she had a lot of work. Taking out a ball of old rags from a large basket, she told me the blood would keep flowing and to put one of the rags between my legs to soak it up.

"But don't be scared. This is normal for all girls."

My fall from the Midget and the story of the blood and everything the nun told me—the truth is I didn't really understand it all, not even half of it. The only thing that was clear was that this would last my entire life, that it would happen every month, and that the blood was for making children, that I too had been born from this blood. The stories of blood and children left me sick. I didn't have anyone to talk to, because I was ashamed and didn't feel like playing, so I ran to the chapel and kneeled down before the statue of Mary, our Virgin—that's what we called her. She was pretty and seemed to be smiling, and with my eyes I could see she was looking at me too. I wasn't alone—in her arms she held a son we called Baby Jesus. It bothered me a little to think that such a lovely child could've been made from the blood of Mary. I looked her straight in the eyes and began to tell her everything, yes, everything I knew about myself—I told her I felt very sad and alone and that I wanted her to be my friend and be able to tell her everything, absolutely everything. When I left, I felt I loved her very much, and from that day forward I

decided to spend every free moment at recess with her. I told her everything about myself. When I had no more to tell, I started to tell her the stories I knew of my friends, and when I was done with those I began to invent fun stories to entertain her—after all, the poor thing spent most of the day and night alone with her little son.

Our friendship was a few days old, many days, and my sadness lingered because I couldn't laugh or be happy and play at recess like I had before. And because I had nothing more to tell her, I decided to ask her for help, to tell her the many things I wanted. I wanted her to help me grow because I wanted to be big like some of the girls. I asked her also to help fix my eyes, because all the girls called me cross-eyed and mocked me by rolling their eyes, and I'd cry and love them a little less. I also asked Mary—I didn't call her Our Lady or the Virgin anymore, we were so close that I called her Mary—I told her I wanted wavy hair, because I didn't like my straight hair and could never make it pretty. I also asked if I could learn to sing. But she never gave me anything that I asked for, and since she didn't talk, I began to turn my back on her and started playing with my friends again.

I almost forgot: the last day I went to visit her, I also told her I wanted to know all the animals. The nuns had told us there were many, many animals in the world, and some were very, very big, as big as the Midget.

When I was little and traveled with Mrs. María, I saw many large animals: cows, bulls, horses, burros, pigs, and other ones called dogs. But here in the

convent we had only very small animals. A sad little cat, a cock that was very mean, two idiot hens, and what we found most frightening, the tiny mice. We also had lots of fleas and lice, but we never saw more than one at a time. Each of them was alone.

Letter Number 20

The nuns and the other girls knew that I'd become friends with Mary, and they also knew I loved her, and I think it was the nuns who told the Mother Superior.

She was waiting for me on my way out of the chapel one day and told me to follow her to the office. She talked at length and beautifully about Mary and about God and said that for me to be close to them, she wanted me to work as the assistant to the nun who took care of the chapel, the sacristan director, Sor Teofilita. At first I was scared—I didn't know if she wanted to punish me—but when I saw her take a piece of candy from her desk drawer, I realized she was offering me this job out of kindness.

The work was long and sometimes lasted late into the night. She told me I wouldn't be obliged to follow the rules like the other girls, that I'd have certain responsibilities. Just hearing that word made me feel that I was being helped by Mary after all.

Sor Teofilita came for me at five in the afternoon. First she showed me the flowers, more beautiful than any I'd ever seen. The ones beneath the Midget were small and ugly and didn't smell as nice as these. She went one by one and told me each of their names—like us, they had names. They were each dressed differently, so lovely and colorful, and when you touched them, each had a different feel. She taught me to treat them very carefully so they wouldn't tear. Some had wonderful odors, and others just smelled like the countryside.

The work was hard. We had to wash the floors of the chapel, the sacristy, and the tiny room near the front where the priest entered to lead mass. We had to change the water in the flower vases every day, something I didn't like at all. I don't know if the flowers pooped and peed, but the vases smelled horrible, and I had to wash the stems too. Of course when the vases were too big, Sor Teofilita helped me bring them down and set them up again. The big holidays were terrible, because we set up twice as many flower vases and twice as many candlesticks. The ordinary candlesticks were copper, but for holidays they were silver, and I was the one who had to clean them, polish them, and set them up. It took me a long time to learn the names of all the vestments, the long shirts and layers, all embroidered, as well as the various rags the priest wore around his neck, around his waist, and on his arms before saying mass . . .

On holidays I'd sometimes not make it to bed until midnight, so exhausted that I'd get under the covers fully dressed; one time the nun who looked after us in the dormitory saw, and she punished me for it, making me kneel in the center of the chapel during mass

for three days, so the other girls and the priest could see I was bad and disobedient. The truth is I only did this three times, and of course the Mother Superior didn't like it, but each time she'd forgive me, threatening that next time she'd take away my job for being unworthy of spending my days before God and Mary. In those days, I didn't know how to read or write, but the kindhearted Sor Teofilita taught me to read the colors on pieces of paper she left me, so I'd know the color of that day's chasuble, or if we needed cloths for the altar or the communion table.

Sor Teofilita and I had a seat and a prie-dieu for kneeling set up in the tiny room at the side of the chapel. We watched mass from here, but when it was time for communion we came into the chapel proper, up to the altar, to receive communion. Afterward I chatted a bit with God and Mary and then raced off to the kitchen swinging a censer through the air as I crossed the four courtyards. I was all alone, and to tell the truth I was so happy in those moments that I even skipped with both feet. There was an old black lady, the cook, named Bolita, and I loved her very much and gave her kisses. She lit the censer for me. Sor Teofilita told me not to believe that was her real name, that they called her that because she was fat with large breasts and sang all day in a tremulous voice. There was another old lady, as bitter as a lemon, who made bread, and after she'd locked up the bakery and gone to her room, we'd tie a fork to a broomstick and steal the bread that sat cooling by the window. After mass I had to run to the kitchen to take the priest his breakfast. The pot was so heavy I held my breath while carrying it so it wouldn't fall . . .

The priest's breakfast was so good, so good, and I wanted so badly to eat it that my mouth watered. Eggs with diced tomato and onion, chocolate, fruit juice, various kinds of bread and pastries made by the nuns, kept in covered tin boxes. On occasion the priest gave me one or two of the pastries, and I would run beneath the stairs to eat them so no one could see me.

Letter Number 21

For Germán Arciniegas:

The keys to the big, heavy door, the one that led
out into the world—those keys were always held by
an old nun we called Sor Doorkeeper. But during
mass she left them with Sor Teofilita, since she sat
just outside the chapel, closer to the door, and could
open it for the milkman, the only one who came at
that hour. Sor Teofilita would place the keys behind
her on the chair, where she rarely sat. She typically
had her face between her hands, praying and praying
all the time.

We called the milkman El Tuerto, One-Eye. Sor
Teofilita told me that he was called this because one
eye was always closed. I asked her why they didn't
wake up that eye, and she told me that he had been
born with it that way. When One-Eye arrived, he'd
come to the door, which had at its center what looked
like a tiny house that spun if it was pushed. This was
the turnstile, and everything we ate came through it.
As he passed the milk through the turnstile, One-Eye

always said, "Ma'am, it's warm, like it was just milked from the udder."

One day I told Sor Teofilita that when I was very small in Guateque, out in the world, I'd once seen a cow. She told me that she had seen cows only in the nativity scenes we made, with the Baby Jesus, son of Mary. When I went to the kitchen with the censer for Bolita to light, or to get the pot with the priest's breakfast, I had to pass in front of the door with the tiny, spinning house. That day I heard something knocking lightly from behind the turnstile. I went closer, frightened, and asked who it was. No one answered, and the turnstile began to spin very slowly, but there was nothing inside, no food. I called out again, asking who it was, and a voice said, "The milk."

"We already have it," I said.

"But I'm the one who brought the milk. In the office, where there are some rags you call curtains, behind them, I made a hole. Go there, and you can see me."

There was indeed a hole there; someone had scratched the white paint off the windows from the outside. The truth is One-Eye frightened me, but my desire to see him was greater than my fear, and I told him through the turnstile to wait. I saw the hole the moment I raised the curtain. It was at the bottom, in a corner. I looked through the hole and found his eye. Yes: we were eye to eye, quite literally, and I liked his eye very much. It was pretty, black at its center, round and very bright. The white was whiter than those I'd seen at the convent. There was another thing I liked: his eye knew how to laugh, and it laughed all the time.

I'd often look at my own eyes in the mirror, and I could never laugh with my eyes the way he did with his. When I didn't see his eye anymore, just the wall, and I heard his footsteps, I waited awhile, but he didn't come back. There was no milk delivered on Sunday, but on Monday I heard the scratching again, and the little house began to turn, and the voice again asked me to go to the hole. He waited for me every day, and our two eyes were so happy to see each other that we felt bad whenever we had to separate.

One day he said: "I'm your boyfriend."

He repeated that word many times. Boyfriend. As soon as I saw Sor Teofilita, I asked what it meant. She laughed and asked who'd taught me that word.

"I don't know," I said. "I heard it somewhere and just remembered it."

I saw in her face that she didn't believe me, and I don't know how, but I remembered that Miss Carmelita, the fat woman who lived in the courtyard full of roses, had told us that her boyfriend left her because she'd gained so much weight. I told Sor Teofilita this, and she laughed and patted me on the cheek.

Our eyes had been meeting for a while, and one day I told him through the turnstile that I wanted him to show me his sleeping eye. His eye immediately disappeared, and he never called on me again and never again showed me his good eye.

I thought about him for a long time, sometimes all day, even during mass, but not just about him—also about that eye of his that had become such a good friend. One day I stopped thinking about it and started thinking about the world. I'd begun to forget my childhood memories of the world with Mrs.

María, and I thought many times of asking the Virgin Mary to help me, to take away that illness she'd given me, to tell her that I suffered thinking all day of One-Eye and of the world. I even offered to say novenas for her, and I did, with great devotion.

Letter Number 22

There were lots of small jobs to be done around the chapel: preparing not only all the clothes the priest had to wear, but also the communion wafers and the cruets—two glass jars, one for the wine and the other for the water. The wine turned into the blood of Christ, who was the same baby Mary had, only now he was grown.

Sor Teofilita told me I didn't know how to clean the corners, and when they were dirty, that was where the Devil lived. It was already late. Sor Teofilita went to sleep, and I stayed to clean the corner where the wine was kept—a corner that, in truth, I hadn't cleaned. In that corner sat a large barrel sent by the Pope, the one who kept the keys to St. Peter in that town far, far away. Of course I was frightened— what if I found the Devil?—but Sor Teofilita had told me that he took only those of mortal sin, and I wasn't one of those. So I started to clean. I found a bottle and removed the cork. I put my finger inside, tasted

it, and liked it. I found a glass, filled it, and had a drink, and then many more; I felt as if I were another person, and in the end I fell asleep on the floor. The German priest was the one who woke me. I saw him kneeling beside me, using his hand to cover my body with blessings. He took me by the hands, lifted me gently, then edged me out of the sacristy. As I left he said, "Don't tell anyone. Not the girls, not the nuns."

That day Mary performed a miracle. Neither the nuns nor the girls realized I hadn't slept in my bed, and I had to confess because it was the Devil who made me drink that wine.

But that wine was also kept by the nuns in other, very beautiful and colorful glass jars, with glass tops, which they saved for "important" visitors. It was essentially Father Bacaus's leftovers. That was his name—Bacaus—though the nuns said it differently from us; we had a hard time pronouncing it. But I haven't told you: that priest had almost no hair on his head, and was dirty, very dirty, with a black cassock I hadn't seen before on anyone else, so old that threads hung from the edges of the sleeves. It was also too small, too short for him, and you could see his hairy legs because he didn't wear socks and his shoes were raggedy and old. The Mother Superior said he dressed that way because he was a saint, a real saint.

Sor Teofilito told me that the wine was sent from the Pope's house far, far away; that on the feast of Saint Peter we sent the Pope gifts made by the girls because all the popes are Peters, because they're like Sor Doorkeeper, the one who guards the keys to the church day in and day out, and that's why the priest drank the wine the Pope sent; and that his country

was called Germany; and his name, as I said, was Bacaus. Since he was a saint, he drank only three drops of wine and left the rest in the jar, and the nuns put it in other jars, which, as I said, were also made of glass of various colors.

The priest Bacaus gave very long sermons that we didn't understand, but because they told us constantly that he was a saint, we had to listen to him until many of us had fallen asleep.

That day was the feast of Saint John Bosco, the one who'd brought the community to life. The nuns were his children; and he, like the nuns, was in charge of the poor children and the dogs who didn't have a family. That Bosco was dead already, but he was still known as a saint.

Mass was led by two priests, with singing by the girls. I worked for a week to prepare, and only Mary saw everything I had to do. Wash all the floors, clean the images of the saints from head to toe; the Christ too had to be cleaned, and I was always anxious about cleaning his wounds, because Sor Teofilita told me dirt and grime were more likely to gather there. I don't know why, if he was in such bad shape, they left him hanging on the cross. I also had to polish all the candlesticks, set up more flower vases, the big ones, and take out the vestments for the two priests—not their everyday clothes but other, more beautiful outfits, shiny from every angle, with many gold ornaments. These vestments weighed much more than the others, so heavy I had to let them fall before I could hang them up. They were only for holidays, and there were even extra layers for the blessing. We had to help dress the priests, and I couldn't manage to hang

everything by myself. Everything was special for the holidays: the goblet was prettier, the cruets prettier. The chapel was transformed.

For the past month, the girls who sang had come to the chapel every afternoon with the Mother Superior. She played the harmonium so beautifully it made me sad. But the Mother Superior made the girls repeat the same song over and over, or sometimes just short sections of it, and she'd get furious and yell that they were out of tune. I forgot to ask Sor Teofilita what out of tune meant.

That day all of us, nuns and girls, walked fast, all in a hurry. Sor Teofilita, so kind, had found me a brand-new uniform, which she gave me as a gift. The old one was getting ragged and short and was starting to feel tight around my chest. Communion came, and we stood up all at once, and it seemed to me the other girls were very happy. I looked at the keys that Sor Teofilita left on her seat and touched them very gently so they wouldn't make a sound, but when I touched them my entire body shivered with cold. Sor Teofilita turned and said, "Go get the censer."

I ran, relieved I hadn't stolen the keys.

After the mass with the two priests, another priest was sent because the saint from Germany was sick. The new priest was very young, and all the girls and the nuns said he was very handsome. All day long I heard the word "handsome, handsome." I was told it meant "pretty." He was from a village called Spain, and those gentlemen from Spain were the ones who'd brought us God, Mary, and all the saints we had in the chapel. He spoke more clearly than the old saint. When I brought him his breakfast, I said, just as the

nuns had taught me, "Good morning, Reverend Father," but he didn't say anything in response.

The little room where the priests had breakfast opened up to the rose garden, where the fat lady lived. The room was very pretty, with lots of light, and in one corner there was a large statue of a saint so big it almost reached the ceiling, and that saint was called Saint Christopher. He was a little old, and he also had a son, but he didn't carry him like Mary carried Baby Jesus, who was also her son. Saint Christopher sat his son on his shoulders, and held him with one arm. The saint looked rushed; one of his legs looked as if it were walking, and even his head seemed to push forward. A nun had told me that the statue had been there for a long time because it was so heavy that no one had been able to move it up the stairs. I didn't like that saint because he always looked to be in such a hurry, and one can't pray to or speak with a saint who's in a hurry.

Letter Number 23

It had been a week since the handsome priest had arrived, and he didn't want the same breakfast as the others. He asked for chocolate in a large jug, because he wanted to drink many cups. He didn't want any more of the pastries the nuns made, the ones they kept in pretty tin boxes. He asked for a kind of bread called *mogollas*, which were darker and heavy and round. He did want his eggs with onion and tomato, but he wanted more because two weren't enough. He also asked for something we hadn't seen before called sausages. They were like sticks made of ground beef and jammed into a container that looked like the skin we had covering our bodies. Since he didn't talk to me or give me pastries, I left his breakfast in front of him on the little table and backed away, bowing, just as Bolita had taught me to do.

What happened took place on a Saturday, because that was the day the nuns gave us off, meaning we

didn't have to work for them but could spend the time mending and washing our own clothes. The nuns left a big basket full of rags and pieces of cloth, which we could take as we wished, to patch holes in our clothes. We never mended our smocks, which had to stay like new. At night when we took off our clothes to put on our nightshirts, first we had to fold our smocks perfectly, as if we were about to iron them, and then, when they were well folded, we put them carefully under the mattress. Since the beds were made of planks of wood, in the morning the smocks were in excellent shape. But the clothes we wore beneath our smocks and nightshirts—those were full of holes, and that was what we did with our Saturdays. The older girls helped the younger girls, of course. Our underwear was always in the worst shape, and we were always asking for new pairs, which weren't really new, just less ragged.

I was telling you that Saturday was the day of disorder, for the girls as well as for the nuns, because we had it off, so we didn't follow the regulations. When I arrived with breakfast, the priest was standing. With a gentle smile he asked me to put the pot on the table. I don't know how it happened, but with a swoop I felt his arm gather me at the waist and his other hand push my head back, and he gave me a kiss on the mouth and then brought his hands down and touched my breasts. I'm sure it was Mary who helped me: I don't know how I thought to kick in the direction of the table, knocking one of the legs and causing the entire breakfast to crash to the floor. The pot made a terrible sound when it fell, so loud even the priest got scared and he just ran. But before he left, he

gave me such a shove that I slammed my head against Saint Christopher. I remember falling to the floor.

They took me to a small empty room where we never went because it was inside the cloister. The kind nuns came to visit and said they were praying for me. Another nun came to tend to the enormous bump on my head. When I'd touch it, I'd cry because I was so scared. When they saw I was starting to improve, the nuns brought me gifts, a little flower, a picture of a saint, sweets. They even gave me a new nightshirt, but they all told me I couldn't say anything, not a word, to my friends, and that if I did I was committing a sin and would be punished.

"You haven't been sick, or been bad" (as they liked to say there). "You've had bad diarrhea. Very bad diarrhea."

When I went back to the sacristy, Sor Teofilita hadn't replaced me with another girl; on the contrary she was, for the first time, affectionate and happy to see me back, but she told me I couldn't take breakfast to the priest anymore. I never saw him again anyway, because they sent us another new priest.

Many days passed, and I was still not well. Everything hurt, and I began to think that this time it was serious. Everything about the convent, the sacristy, the nuns, the priests, Mary and her son, all of it made me suffer, and I felt I didn't want to see them again. My friends looked to me as if they'd been drained of their color, and since I couldn't talk to any of them, I thought I didn't love them anymore. They hadn't done me wrong, but they forced me to think about what had happened.

When I was back at the sacristy, Sor Teofilita told me gently that a new priest was coming. She talked a lot about him, assuring me he really was a saint. It was the first time I thought to ask her what she meant by "saint," and she said it was someone who went straight to heaven when they died . . . I don't know what the new priest was like; I didn't look at him. All I saw were the keys that Sor Teofilita kept on the chair, the keys that I watched from the corner of my eye. There was a knock on the door, and she ran to open it. Without prompting, she whispered in my ear: "One-Eye doesn't come with the milk anymore."

When communion came, we stood up all at once, as usual, and then returned to our seats, kneeling, as we always did, with our faces in our hands so we could talk to God. I didn't talk to God or to Mary but to Saint Christopher and asked him to carry me on his shoulders. I raised my head, stretched my arm behind Sor Teofilita, and, very slowly with my fingers stretched wide, I took the keys, clutching them tightly so they wouldn't make a sound. I said, in a voice that was almost loud, "I'm going for the censer."

She didn't see me. She was praying. I unlocked the door to the hallway and locked it again from the other side. I opened the heavy door, turned back, placed the keys on the turnstile, and gave it a spin so the nun would find them when she got back. I left very slowly, so frightened I felt as if a hole might swallow me up, and when I closed the heavy door, I breathed an air that didn't smell like the convent. A cold wind blew, and I felt as though it had come from behind the door to scare me; but it was too late for all that. The street was long and sloped upward. In the

distance I glimpsed part of a church tower. Before moving farther into the world, I realized it had been a long time since I was a girl. There was no one in the street, except two dogs, one of them sniffing the other's backside.

Bordeaux 1997.